Medieval Wall Paintings

E. CLIVE ROUSE

SHIRE PUBLICATIONS LTD

COVER: Longthorpe Tower, Cambridgeshire. Part of the vault: King David playing the harp. Circa 1330. (Watercolour by the author.)

British Library Cataloguing in Publication Data: Rouse, E. Clive (Edward Clive), 1901- Medieval wall paintings. — 4th edition. I. Title. 751.730942. ISBN 0-7478-0144-4.

Copyright © 1968, 1971, 1980 and 1991 by E. Clive Rouse. First published 1968 as 'Discovering Wall Paintings', number 22 in the 'Discovering' series. Second edition 1971. Third edition 1980. Fourth edition 1991 as 'Medieval Wall Paintings'. ISBN 0747801444.

All rights reserved. No part of this publication may be reproduced or transmitted in any form or by any means, electronic or mechanical, including photocopy, recording, or any information storage and retrieval system, without permission in writing from the publishers, Shire Publications Ltd, Cromwell House, Church Street, Princes Risborough, Buckinghamshire HP17 9AJ, UK.

Printed in Great Britain by C. I. Thomas & Sons (Haverfordwest) Ltd, Press Buildings, Merlins Bridge, Haverfordwest, Dyfed SA61 1XF.

CONTENTS

List of illustrations	4
Introduction	7
Paintings were universal in churches	9
The purpose of wall paintings	13
Artistic status	19
Characteristics of English medieval murals	21
Domestic or secular paintings	26
Where to look for paintings	30
The subject matter of medieval wall paintings	35
1. Decorative schemes	35
2. The Bible story	38
3. Single figures of saints	45
4. Lives of the saints	50
5. Moralities	57
Post-Reformation paintings	71
Further reading	72
Gazetteer	
Index	79

ACKNOWLEDGEMENTS

Warm thanks are due to Ann Ballantyne and Pauline Fenley for their indispensable assistance and to the incumbents of parishes and to other church authorities whose wall paintings appear in this book.

The cover and plates 5, 11, 12, 13, 26, 28, 31, 34, 35, 36, 37, 38, 41, 42, 43, 46, 48, 49, 50, 51, 56, 62, 67, 68, 70, 71, 74, 77 and 78 are watercolours by the author and were photographed by Michael Bass, except plates 28, 46, 62 and 74 which were photographed by Fiona Spalding Smith and plates 71

and 77 which were photographed by Ann Ballantyne.

Further acknowledgements for illustrations are as follows: Ann Ballantyne, plates 6, 7, 8, 9, 10, 14, 21, 22, 25, 27, 39, 40, 44, 45, 52, 53, 54, 55, 58, 69, 73, 75 and 76; by kind permission of the Dean and Chapter of Durham Cathedral, plate 16; Sir George Godber, plate 72; Mary Hildesley, plate 61; Cadbury Lamb, plates 2, 3, 4, 15, 17, 20, 23, 24, 32, 33, 47, 57, 59, 60, 63, 79 and 80; by kind permission of Arthur Lindley, plates 29 and 30; E. A. Sollars, plate 18; Dr E. W. Tristram and Walter Scott, Bradford, plate 19; Ralph Wood, plates 64 and 65.

LIST OF ILLUSTRATIONS

Colour illustrations are denoted by an asterisk (*).

- 1. Stoke Dry: Martyrdom of St Edmund; St Christopher page 6
- 2. Pickering: view of late fifteenth-century paintings on north arcade page 8
- 3. Pickering: St Christopher and the Holy Child page 8
- 4. Pickering: St George and the Dragon page 8
- 5. Peakirk: miracle of Longinus, detail from the Passion cycle page 10 *
- 6. Coombes: figure supporting arch and 'double axe' pattern page 11 *
- 7. Ickleton: Last Supper; Betrayal; St Peter; St Andrew page 12
- 8. Corby Glen: Herod; shepherds on the way to Bethlehem page 12
- 9. Castor: scene from the Life of St Catherine page 14 *
- 10. Sporle: Life of St Catherine page 14 *
- 11. Coombes: three prying or disbelieving Jews page 15 *
- 12. Coombes: man talking to Herod page 15 *
- 13. Coombes: Annunciation page 15 *
- 14. Sporle: St Catherine mocked page 16
- 15. Lakenheath: St Edmund page 16
- 16. Durham Cathedral: St Cuthbert page 17
- 17. Chalfont St Giles: Herod's feast page 18
- 18. Winchester Cathedral: detail of angel roundels page 19
- 19. Canterbury Cathedral: St Paul and the viper page 20
- St Albans Cathedral and Abbey Church: Crucifixion and Virgin and Child page 22
- St Albans Cathedral and Abbey Church: Crucifixion and Virgin and Child page 22
- 22. St Albans Cathedral and Abbey Church: Crucifixion and Annunciation page 22
- St Albans Cathedral and Abbey Church: Crucifixion and Coronation of the Virgin page 22
- 24. St Albans Cathedral and Abbey Church: St Thomas à Becket page 22
- 25. St Albans Cathedral and Abbey Church: female saint page 22
- 26. Coombes: detail of painted arcading on chancel arch wall page 24
- 27. Gloucester Cathedral: story of Reynard the Fox page 27
- 28. Longthorpe Tower: head of King Reason from Wheel of the Five Senses page 28
- 29. Piccotts End: Baptism of Christ page 28
- Piccotts End: St Peter; Pietà; Christ in Majesty; Baptism of Christ; St Clement page 29 *
- 31. Longthorpe Tower: St Anthony Abbot and Labours of the Months page 29 *
- 32. Little Missenden: St Christopher; Life of St Catherine with the wheel breaking asunder page 31
- 33. Little Hampden: St Christopher page 31
- 34. St Davids Cathedral: roof vault with owl and magpies page 32 *
- 35. St Davids Cathedral: roof vault with symbols of the evangelists page 32 *
- 36. Stoke Orchard: window splay depicting part of Life of St James the Great page 33 *

LIST OF ILLUSTRATIONS

- 37. Coombes: lion of St Mark page 33 *
- 38. Llantwit Major: St Christopher and the Holy Child page 34
- 39. Hardham: scenes from the story of Adam and Eve page 36 *
- 40. Wisborough Green: head of Christ; St James of Compostella (?); Crucifixion with miracle of Longinus page 36 *
- 41. Peakirk: scheme of painting on north wall of nave page 36 *
- 42. Llantwit Major: tessellated pattern page 37
- 43. Coombes: imitation masonry pattern page 37
- 44. Great Burstead: Annunciation and Nativity page 39
- 45. West Chiltington: part of a Passion cycle page 39
- 46. Corby Glen: St Anne and the Virgin Mary page 40
- 47. Easby: scenes from the story of Adam and Eve page 41
- 48. Coombes: Flight into Egypt page 42 *
- 49. Ulcombe: parable of Dives and Lazarus page 42 *
- 50. Peakirk: Christ washing the disciples' feet page 43 *
- 51. Padbury: miracle of St Edmund's head and the wolf page 43 *
- 52. Bradwell Abbey: St Anne teaching the Virgin page 44
- 53. Bradwell Abbey: Annunciation page 44
- 54. Whitcombe: St Christopher page 45
- 55. Hayes: St Christopher page 46 *
- 56. Corby Glen: St Christopher page 47 *
- 57. Little Kimble: burial of St Catherine; St Bernard page 49
- 58. Nether Wallop: St George and the dragon page 49
- 59. Little Kimble: St George page 49
- Pickering: Martyrdom of St Thomas à Becket; Martyrdom of St Edmund page 50
- 61. Wareham: story of St Martin page 50
- 62. Stoke Orchard: part of Life of St James the Great page 51
- 63. Little Kimble: Martyrdom of St Margaret page 52
- 64. Battle: Life of St Margaret of Antioch page 53
- 65. Battle: panels from Life of St Margaret page 54
- 66. Salisbury: repainted Doom in St Thomas's church page 56
- 67. Corby Glen: Last Judgement page 58 *
- 68. Stanion: St Michael with the scales of justice page 59 *
- 69. North Cove: the Virgin in supplication, part of Last Judgement page 60
- 70. Corby Glen: warning to blasphemers page 62 *
- 71. Tarrant Crawford: the three kings from the Three Living and the Three Dead
- 72. Breage: warning to sabbath-breakers page 63 *
- 73. Arundel: the head of the sin of Pride page 64
- 74. Padbury: the Seven Deadly Sins page 64
- 75. Ruislip: the Seven Deadly Sins page 65
- 76. Trotton: Christ in Judgement with Seven Deadly Sins and Seven Corporal Works of Mercy page 65
- Tarrant Crawford: the three skeletons from the Three Living and the Three Dead page 66
- 78. Peakirk: warning against idle gossip page 69
- 79. Easby: pruning, from Labours of the Months page 70
- 80. Little Hampden: St Peter page 73

MEDIEVAL WALL PAINTINGS

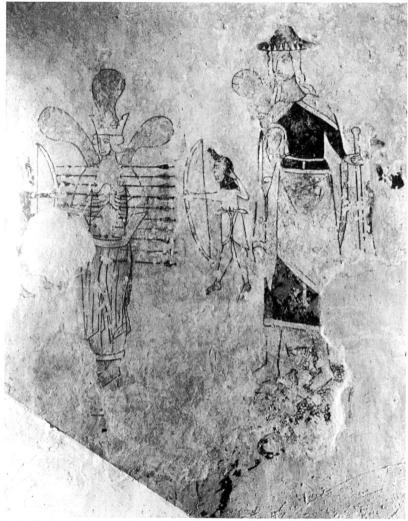

1. Stoke Dry, Leicestershire. (Left) The Martyrdom of St Edmund, shot by two Norsemen; (right) St Christopher. Fourteenth century.

Introduction

The impression carried away by many people visiting an English church containing wall paintings often tends to be one of disappointment. Sometimes it is one of bafflement or frustration, even anger. For most wall paintings in smaller country churches in England are fragmentary; many are dirty, neglected, obscure and in poor condition, and difficult to decipher and understand. There are of course many shining exceptions where trouble has been taken to clean and preserve paintings. But even so they are not always easy to interpret. Few churches ever bother to have a leaflet explaining their wall paintings.

Up to the 1920s English medieval art was a subject almost wholly neglected, the view being that there was nothing to compare with wall paintings on the Continent. There has, however, been a great revival of interest in English medieval art and architecture in recent years. The wonderful work carried out by the late Professor Tristram, inspired by W. R. Lethaby and W. G. Constable, in uncovering, recording, publishing and bringing to public notice the great value and interest of English medieval wall painting, cannot be over-emphasised. England is still one of the few countries in Europe that has no official body to look after its treasures in this field. It is still left to the individual whim of incumbents or church councils to bother or not, as they choose, about dealing with wall paintings in their churches. There is grudging support for those who do care, from Diocesan Advisory Boards, and a parish may be prevented from actually destroying wall paintings though even this is not unknown. The Pilgrim Trust and other charitable bodies have made generous grants towards the conservation of wall paintings, under the general control of the Council for the Care of Churches, and English Heritage has greatly increased grants for restoration. But money has to be raised by the individual churches concerned, and consequently many paintings deteriorate or fail beyond recovery through inertia and neglect. Much of this is due to lack of understanding of the subject by so many people. And so it is hoped that this small book will do something to point out the interest and importance of ancient wall paintings and their contribution to art, history, sociology and teaching, apart from their religious aspect.

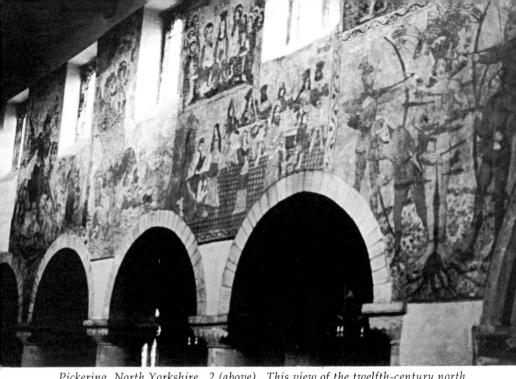

Pickering, North Yorkshire. 2 (above). This view of the twelfth-century north arcade gives an impression of a completely painted church. The paintings are late fifteenth-century and include (from left to right) St George, St Christopher, the Coronation of the Virgin above Herod's Feast and the Martyrdom of St Edmund. 3 (below left). North arcade: St George and the Dragon. 4 (below right). North arcade: St Christopher and the Holy Child. (The south arcade is also extensively painted.)

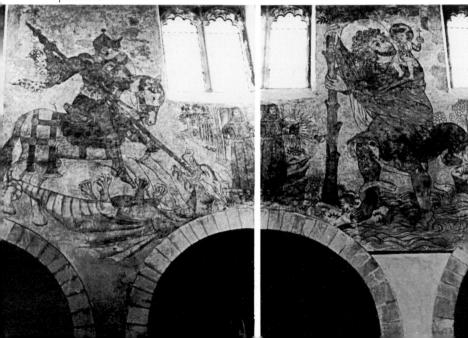

PAINTINGS WERE UNIVERSAL IN CHURCHES

It must be realised that all medieval churches in England were more or less completely painted. Not all had many figure subjects but most had some, as will be discussed later.

It may well be asked, if this were really so, why we do not see more of them. The answer is threefold. First of all, the medieval artist never intended his painting to last forever. Paintings were constantly being replaced as they became dilapidated or unfashionable; and as the churches themselves were altered or enlarged, so the need for fresh murals grew. In the second place, all wall paintings, screens and painted carved images were obliterated at the Reformation, the walls being covered with limewash, on which texts were subsequently painted, as will be described later. But the third cause of the disappearance of wall paintings is by far the most devastating. Whereas the reformers in the sixteenth and seventeenth centuries contented themselves with obscuring the offending imagery with limewash, the Victorians caused wholesale destruction by prejudice and ignorance, and by the wicked and senseless practice of stripping plaster (whether sound or not) from the walls 'to show the beautiful stonework' — which was never meant to be seen. The rough rubble masonry and even reasonably good dressed stonework were deemed unworthy; it was the skeleton, the bare bones of the building, which was meant to be decently clothed with plaster and adorned with paintings. Literally hundreds of wall paintings were destroyed in the nineteenth century in this way.

It is often pointed out that the greater proportion of paintings occur in the south-east of England, in Norfolk, Suffolk, Essex, Kent, Surrey, Sussex, Buckinghamshire, Berkshire, and so on. What is the reason for this: were there not so many paintings in the north? The answer is that in most of the counties listed above there is no easily accessible good building stone, and the walls tend to be of stone rubble, flint or chalk rubble, which you cannot strip, and so the paintings have survived. Whereas in the north, the climate is perhaps more inimical to the survival of wall paintings, and there the stone tends to be better and larger, and the temptation to expose it greater. Consequently any paintings on the plaster so removed have gone for ever.

MEDIEVAL WALL PAINTINGS

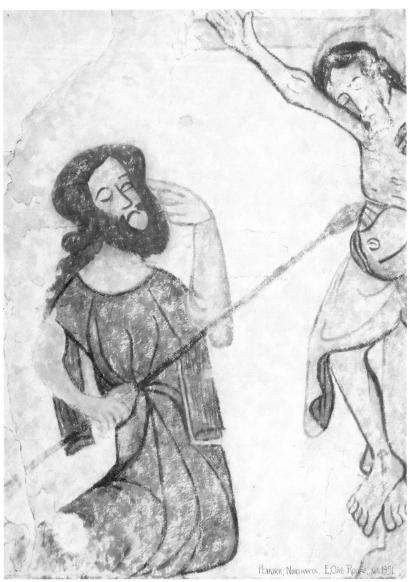

5. Peakirk, Cambridgeshire. A detail from the Passion cycle, showing Longinus piercing Our Lord's side and miraculously receiving his sight. It is one of the finest examples of this subject. (Watercolour by the author.)

PAINTINGS WERE UNIVERSAL IN CHURCHES

6. Coombes, West Sussex. The crouched figure beneath a 'double axe' pattern on the soffit of the chancel arch appears to support the masonry above. Circa 1100.

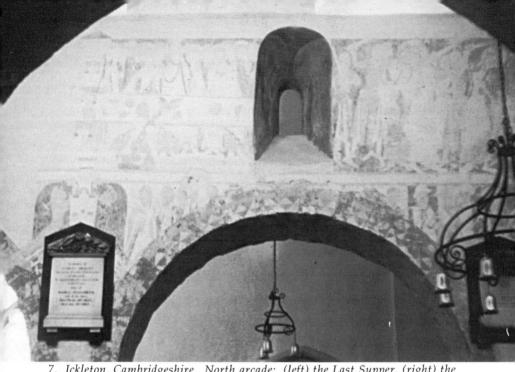

7. Ickleton, Cambridgeshire. North arcade: (left) the Last Supper, (right) the Betrayal, (below left) the Martyrdom of St Peter and (below right) the Martyrdom of St Andrew.

8. Corby Glen, Lincolnshire. South wall: (left) Herod (?) and (right) shepherds on the way to Bethlehem.

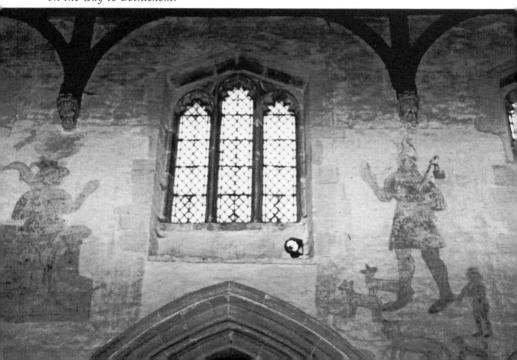

THE PURPOSE OF WALL PAINTINGS

Most people suppose that the object of having wall paintings in a church was purely for decoration, in the same way as you now hang a framed picture on your dining-room wall. This is not so and should be realised at once. Far too many people merely regard a wall painting from the point of view of its artistic merit. Is it a good picture? This was not uppermost in the mind of the medieval painter. He had two objects in view and they were crystal clear. He was there to be devotional: and he was there to teach.

The first object is obvious and needs no elaboration in an age when there was only one religion and everybody knew all about it, instead of the position today when there are endless religions and sects — or none at all.

The second — the teaching aspect of medieval wall paintings — is not sufficiently realised and perhaps needs more explanation. Up to the end of the fifteenth century there were no printed books. Service books, and such Bibles and religious books as there were, had to be laboriously written out by hand and were expensive, few in number and possessed only by privileged persons. In any case, if books of any sort had been generally available, probably 80 per cent or more of the average village congregation could not have read them — they were illiterate — and the books tended to be in languages they did not understand: Latin and French.

So, how was the harassed parish priest (himself often no scholar) to impress the Bible story, the lives of the saints and the moral teachings of Christianity on his illiterate flock? This was largely done, or assisted, by the paintings on the church walls — the *Biblia Pauperum*, or Poor Man's Bible, as they have been called. They might be likened to the 'visual aids' of modern education, or even to the strip cartoon, intended for quick visual assimilation and not for serious digestion. They had to explain themselves by their pictorial content alone. And to achieve this, certain conventions or deliberate exaggerations were introduced. It is important to understand these, or a very wrong impression of English medieval painting in the average village church will be formed. In the great abbey and cathedral churches there is more sophistication: the monks and canons and the congregation generally were better educated. The artistic standard is higher, and there was not the same need for conventions for teaching, and for moralities. This is well seen in places like Westminster,

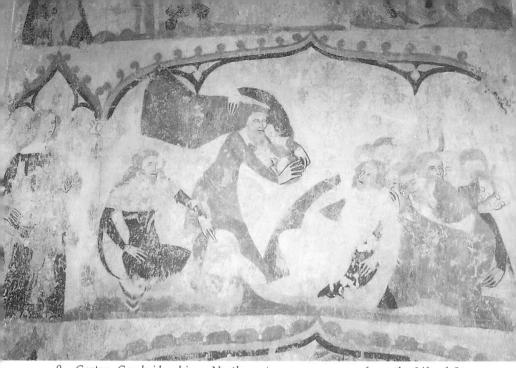

9. Castor, Cambridgeshire. North-west corner: a scene from the Life of St Catherine. Catherine, a Christian queen (left), opposed the Emperor Maxentius when he tried to make her people worship idols; the Emperor then commanded philosophers to prove his point but instead they were converted and so he ordered them to be thrown into a fire (right). Fourteenth century.

10. Sporle, Norfolk. The Life of St Catherine, including the breaking of the wheel. Fourteenth century.

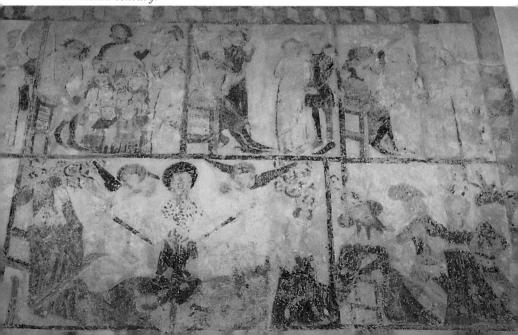

Coombes, West Sussex. 11 (above). South wall of nave: three prying or disbelieving Jews. 12 (below left). North wall of nave: man talking to Herod. Note the hand gesture denoting speech. 13 (below right). South wall of nave: the Annunciation. The gestures of the angel and Mary denote his salutation and her response. The colouring of these early twelfth-century paintings would have been produced by skilful mixing of only black, white, red and yellow. (Watercolours by the author.)

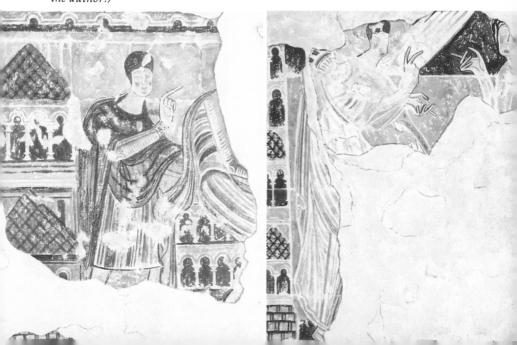

MEDIEVAL WALL PAINTINGS

St Albans, Norwich, Canterbury, Winchester and Durham.

But the village congregation needed help. So a complete code of signs, attitudes, attributes and gestures was introduced, simply for ease of recognition. Good people had haloes and were beautifully drawn. Bad people — wicked emperors, torturers, executioners — were often made deliberate caricatures with hook noses, hump backs, comic hats or exaggerated clothes. Crowns, gloves, swords were made larger to emphasise rank, position, authority and cruelty.

There was a complete code of signs and gestures. The *Blessing* is well known, and there are two forms of it, the Greek being the earlier, where the thumb and third finger are together, whereas in the later the third and fourth fingers are folded in, the thumb and first and second fingers being

14 (left). Sporle, Norfolk. St Catherine mocked. Her tormentors have curious hats and are sticking their tongues out. Fourteenth century.

15 (right). Lakenheath, Suffolk. St Edmund, King and Martyr. Fourteenth century.

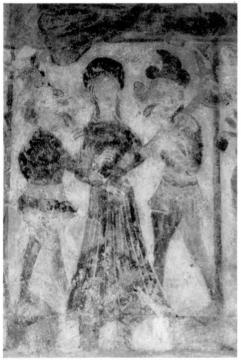

THE PURPOSE OF WALL PAINTINGS

extended and symbolical of the three persons of the Trinity. Judgement was indicated by the open palm, Condemnation by the single finger pointing. Two fingers denoted *Power* — often the *Manus* Dei or Hand of God emerging from a cloud. The curved finger showed Speech; hands up-raised Argument or Expostulation; hands and arms outspread lower down, Wonder, Adoration or polite Listening. Again in an early form, the arms are crossed in the Blessing. The crossing of the legs was important. It was held to be an interruption of the normal flow of life (as seen on early tomb effigies) and became the attribute of wicked emperors — the only ones who could do it with impunity. Hands placed together or clasped in a variety of ways denote Prayer or Supplication.

Apostles, saints and martyrs carry objects or emblems, usually associated with their martyrdom or some prominent episode in their lives, purely for recognition purposes and as a reminder of their lives and deaths.

Another convention decreed that the soul should always be represented by a small naked figure, rank or status being indicated (somewhat incongruously) by the wear-

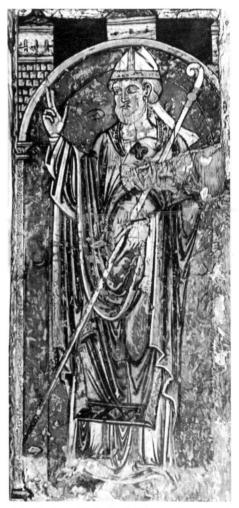

16. Durham Cathedral, County Durham. Galilee Chapel: St Cuthbert. Twelfth century.

ing of crowns, mitres or tonsure. The medieval peasant or itinerant artist could often get his own back on 'the establishment' by representing kings, queens, bishops, abbots and priests in the procession of naked souls being dragged off to Hell, in paintings of the Doom.

MEDIEVAL WALL PAINTINGS

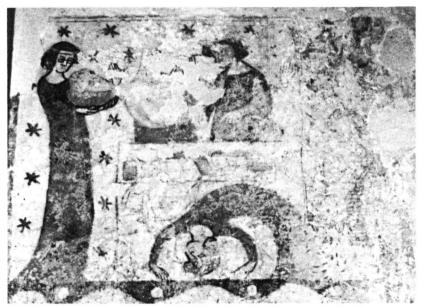

17. Chalfont St Giles, Buckinghamshire. Herod's Feast: Salome dances as John the Baptist's head is brought on a platter.

Costume is important. People in the paintings were put into contemporary costume — twelfth-, thirteenth-, fourteenth-century or whatever it may be — so as to aid easy recognition of their rank, status or occupation. And this, as in the brasses, is valuable for dating, and as sociological and historical evidence.

Another convention with which the student of medieval wall painting must become familiar is the 'telescoping' or running together of several moments or incidents of a story into one scene. The gestures in a painting of the Temptation and Fall often suggest in one scene the fact of Eve's temptation, her giving the fruit to Adam, and his eating of it. Salome often appears twice in one scene both carrying in the head of the Baptist in a dish and dancing at the feast of Herod and Herodias. In the miracle of Longinus, four separate moments are often shown in one scene: his blindness by showing one eye closed; his piercing of Our Lord's side on the Cross; his miraculous recovery of sight by drops of the sacred blood falling in his eyes (the other eye open, and his hand pointing to it); and finally his kneeling to acknowledge the miracle and his conversion (as at Peakirk, Cambridgeshire).

ARTISTIC STATUS

We have lost such an enormous proportion of wall paintings that it is difficult to form any accurate assessment of the true artistic merit of English wall paintings as a whole. From the best of what has survived it is clear that there must have been very many paintings of the highest quality in each century from the twelfth to the fifteenth. And these can challenge comparison with many on the Continent. There were well recognised artistic centres or 'schools' in England just as much as on the Continent, East Anglia being prominent in the middle ages, as it was for secular painting in the eighteenth and early nineteenth centuries. Not many murals survive in these places or can be associated with them, and our evidence must be largely based on the production of manuscripts in the *scriptoria* of various great religious houses that can be definitely attributed to individual places. Of these the most important are Westminster, where the Royal or Court School flourished; St Albans, particularly under Matthew Paris in the thirteenth century; Norwich; Bury St

18. Winchester Cathedral, Hampshire. Guardian Angel's Chapel: detail of angel roundels in the vault. Mid thirteenth century.

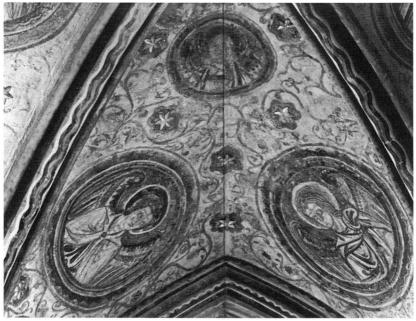

MEDIEVAL WALL PAINTINGS

Edmunds; Peterborough; Canterbury; and Winchester. In all these places, except Bury St Edmunds and Peterborough, important paintings do survive.

That there were many other competent artists available for work in humbler places (some of them commissioned by a wealthy lord of the manor, no doubt, and borrowed from distinguished establishments) is shown by paintings in such places as Kempley (Gloucestershire), Clayton (West Sussex), Coombes (West Sussex), South Newington (Oxfordshire), Little Wenham (Suffolk), West Chiltington (West Sussex), Chalgrove (Oxfordshire) and elsewhere. But, for the average village church, the object was different as artistic competence was of secondary importance.

19. Canterbury Cathedral, Kent. St Anselm's Chapel: St Paul at Malta, shaking the viper off his hand. Before 1174.

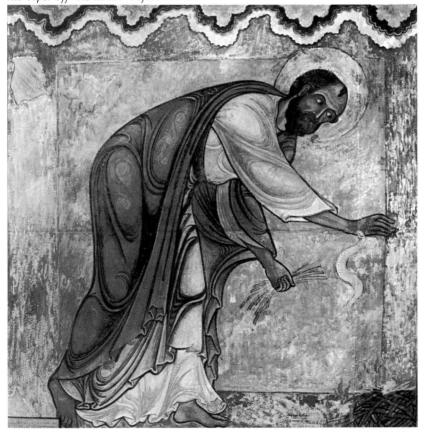

CHARACTERISTICS OF ENGLISH MEDIEVAL MURALS

This brings us to the consideration of the main characteristics of English medieval painting. And it is above all skill, sureness and purity of outline, particularly in the thirteenth and early fourteenth centuries, when English painting was freed from Norman and other continental influences and was at its height, that are the salient features. On the Continent artists were more concerned with elaborate colouring and solid filling in of draperies and shading, whereas their English counterparts concentrated on the linear essentials — sometimes the minimum of what was needed to convey the meaning of the subject. Indeed, artistically poor, even crude, though some of the English village church paintings are, their naive directness, simplicity and utter sincerity are often far more moving and more effective than a more self-conscious and elaborately finished work of art.

THE PAINTERS

Who were these men? For the most part they remain unknown, at least those responsible for paintings in humble village churches, probably journeymen painters moving from place to place.

The names of a number of artists and craftsmen working under royal patronage in the thirteenth and fourteenth centuries have survived in the royal household accounts — the Liberate and Close Rolls. Under Henry III and Edward III in particular there are extensive lists of names. Even an account of what they were to paint at Westminster, Clarendon, Windsor, Winchester and elsewhere is given, and the nature and cost of their materials: 'vert de greece' (a copper green), 'squirrel's hair for the painters' pencils' and so on. The name of Matthew Paris himself occurs. He was a remarkable man, sacrist of the great Benedictine abbey of St Albans, a working goldsmith, artist, illuminator, historian, chronicler and church reformer who went on a mission to Scandinavia, where his influence was such that many Norwegian paintings of thirteenth-century date show strong English characteristics. The names of such men as Walter of Durham and Walter of Colchester (the latter himself described by Matthew Paris as *pictor incomparabilis*) are found. Matthew's brother Simon and his nephew Richard were also painters with him at St Albans. Some of these men painting at Westminster and St Albans were monks. But many were not, like Alan, Master Peter, Master Walter and Master

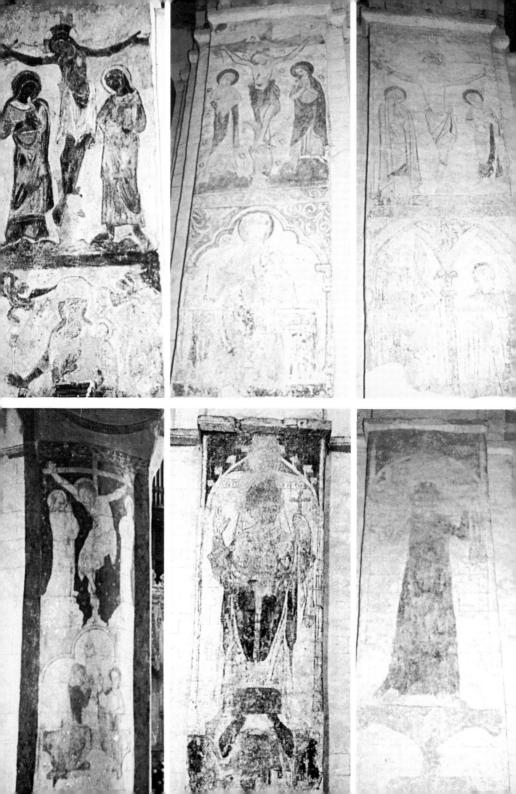

CHARACTERISTICS OF ENGLISH MEDIEVAL MURALS

Thomas, who were all laymen and were employed by Edward I at Westminster.

Far too many works are attributed to 'the monks'. It is true that any boy or man showing artistic promise would have been trained in the monastic *scriptorium*—there was nowhere else to learn. He would run errands, prepare inks, paints and parchment and act as scribe in preparing service books, Bibles, psalters and so on. He might become a miniaturist or illuminator: he might paint murals or prepare cartoons for stained glass. But he did not necessarily take orders or become a monk. Many did indeed become travelling artists and craftsmen, their later successors no doubt coming under the control of the Plasterers' or Painter-stainers' Guilds in the City of London and other places.

TECHNIQUE AND MATERIALS

Mention of some of the painters' materials in the last section raises the question of the technique and materials employed in English medieval wall paintings. Murals are often loosely termed frescoes. Indeed all frescoes are murals, but by no means all murals frescoes. The term fresco ('fresh', or 'wet') implies a particular technique hardly ever found in England, but common on the Continent, particularly in Italy, Spain and Greece. The artist and plasterer worked together. The rough outline

FACING PAGE: St Albans Cathedral and Abbey Church, Hertfordshire.

- 20 (top left). West face of west Norman pier, north side of nave: Crucifixion (circa 1215) and Virgin and Child (known to have been covered by 1400).
- 21 (top centre). West face of second Norman pier from west, north side of nave: Crucifixion (second quarter of the thirteenth century) and Virgin and Child in an architectural setting similar to the chapter house at Westminster Abbey (thirteenth century).
- 22 (top right). West face of third Norman pier from west, north side of nave: Crucifixion (circa 1250-60) and Annunciation (thirteenth century). By 1400 the cult of the Virgin had so developed that the angel would have knelt to her.
- 23 (bottom left). West face of fifth Norman pier from west, north side of nave: Crucifixion (circa 1275) and Coronation of the Virgin of similar date.
- 24 (bottom centre). South face of second Norman pier from west, north side of nave: St Thomas à Becket. Second quarter of fourteenth century.
- 25 (bottom right). South face of third Norman pier from west, north side of nave: a female saint, possibly St Citha (Osyth), with a rosary.

MEDIEVAL WALL PAINTINGS

26. Coombes, West Sussex. Detail of south side of nave face of chancel arch. The painted arcading is considerably later than the fragment on the right of a figure from the adjacent painting, circa 1100. (Watercolour by the author.) For colour pictures of Coombes see pages 11, 15, 33 and 42.

(called the *sinopia*) was set out in bold strokes on a basic coat of plaster. This was then covered by a thin finishing coat of plaster on which the artist worked, from a cartoon, while it was still wet, the pigments sinking right into the surface. Only so much plaster was put up as the artist could cover while it was in the right condition. That is why many Italian wall paintings can be seen to be in rectangular sections, and the haloes are often in slight relief. The early paintings at Kempley (Gloucestershire) and the West Sussex group of Hardham, Clayton and Coombes are largely in this technique. Some others have become frescoes, *fresco buono*, almost by accident, probably through the dampness in most English church walls! The fresco technique was evidently found unsuitable in England, owing to poverty of walling materials and inimical climatic conditions. A fresco will last almost indefinitely, if it is on the inside of a solid marble wall in a sunny climate. But it is a very different matter on thin chalk rubble in damp and cold conditions.

CHARACTERISTICS OF ENGLISH MEDIEVAL MURALS

The method employed in England is the *secco* technique. In other words, the whole wall was completely plastered and given a finishing coat or painting surface in lime-putty. This would have been damped and painted on with basic earth colours, with a clear lime water as vehicle, fixed in all probability with skim milk (casein), which was certainly used with limewash. Egg tempera, or occasionally oil or parchment size, was reserved almost exclusively for manuscript painting and screens or monuments over gesso, though some of these media are not unknown in murals.

The pigments were of the simplest. Oxides of iron are the commonest — red and yellow ochre, which even in themselves had a wide range, the red ochres going almost from purple to pale red. Lime white and lamp or charcoal black gave an added variety. Vermilion, a sulphide of mercury, is found, but this was a difficult and expensive colour to make and is unstable in lime painting, tending to blacken in certain conditions. Greens were generally a coppersalt. Blue is rare and is usually an azurite, though lapis lazuli is not unknown.

The skilful mixing of only two colours, plus black and white, at Coombes shows what a rich range and effect can be produced: deep red, down to the palest pink; deep yellow, almost brown, through to the palest cream; grey; and a colour one would almost swear to be blue but that is in fact black and white with a touch of red.

Occasionally the technique of using a dark under-painting for flesh tints was employed in work of exceptional quality (St Albans; Little Wenham, Suffolk; Longthorpe, Cambridgeshire, *et cetera*).

Later paintings tend to have a wider range and more subtle colours but, being often derivative, are not always so permanent.

DOMESTIC OR SECULAR PAINTINGS

We have been concerned so far almost entirely with wall paintings in churches. This is not surprising, because hardly any domestic paintings of medieval date survive. But they must have been common in most larger houses. Reference has already been made to painters working at Westminster, Windsor, Clarendon and Winchester, for royal patrons. These were not merely, or indeed mainly, in the churches, but in the apartments of the royal castles or palaces.

It is one of the great tragedies of the nineteenth century that the old Palace of Westminster was destroyed by fire in 1834. The Painted Chamber, the Antioch Chamber, the Queen's Chamber and other apartments were completely painted, and the paintings renewed at different dates. They are meticulously documented, and some records were made before and after the fire, showing the work to have been of the highest quality. Most of the subjects were biblical. There is no reason to suppose that most castles and great houses of medieval date were not similarly decorated, but most of the castles are now ruinous or destroyed, and the larger houses so altered at later dates that no paintings survive.

At Windsor in 1965 a fragment of painting (part of a series of roundels with apocalyptic scenes) was found in what had been an anteroom or great chamber connected with Henry III's Great Hall. At Salford Manor, Avon, a fragment of a wheel (probably of Fortune) and an Annunciation survive. At Cothay Manor in Somerset there are several fragments, including a tournament scene, and a fox hanged on a gibbet by geese—part of the story of Reynard the Fox popular throughout the middle ages (fifteenth century).

But by far the most remarkable survival is the complete room or Great Chamber of Robert de Thorpe at Longthorpe Tower near Peterborough, giving us an idea of the scope and richness of painting that must have been common even in modest houses, let alone great ones, in the middle ages. The paintings were found just after the end of the Second World War where the Home Guard had loosened some whitewash and distemper. The entire room is covered with paintings of superb quality of about 1330. It has been described as representing 'a spiritual encyclopaedia', combining biblical, moral and didactic and even secular subjects fashionable at that particular date. There is the Nativity; the Apostles' Creed with a commentary; the symbols of the evangelists with King David playing the harp amid a group of other instruments; the Three Living and

DOMESTIC OR SECULAR PAINTINGS

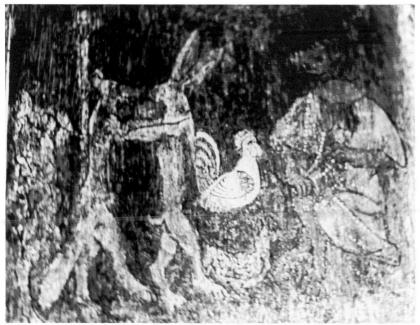

27. Gloucester Cathedral, Gloucestershire. The back of the choir stalls, in the Dean's vestry: the story of Reynard the Fox. Reynard is bound by Couard the Hare and brought for judgement before Ysangrin the Wolf by Chanticleer the Cock and Pinte the Hen. Fourteenth century.

Three Dead; the Wheel of the Five Senses; the Wheel of Life or Seven Ages of Man; the Labours of the Months; St Anthony Abbot; St Paul; and two throned figures and a *Bestiary* subject together with heraldry and birds. It is now in the hands of English Heritage and is open to the public.

The sixteenth and seventeenth centuries saw much painting in smaller houses. And, oddly enough when figure subjects were frowned on in churches, they occur quite often in houses: the Prodigal Son, Tobit and the Angel, Elijah fed by Ravens, Moses and the Egyptian, David and Goliath, Judith and Holofernes are all found. The Nine Worthies were a favourite subject (Amersham, Buckinghamshire; Harvington Hall, Worcestershire). But by far the greater number of domestic paintings of late Tudor (Elizabethan) and Jacobean date are decorative, often with a frieze having text panels and various forms of painted representations of panelling. There are many examples in black and white in the classical manner in the style known as 'the antique' or 'grotesque', clearly derived

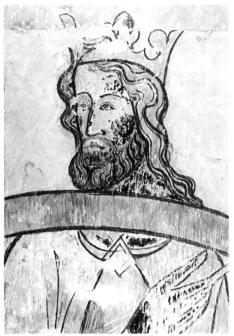

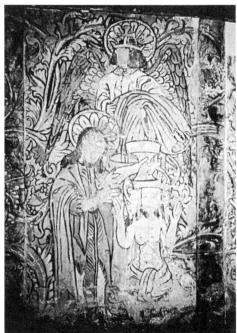

28 (left). Longthorpe Tower, Cambridgeshire. East wall: the head of King Reason, a detail from the Wheel of the Five Senses. King Reason stands behind a wheel on which there are animals representing the five senses. The picture is an exhortation not to rely too much on the senses, which are controlled by Reason. Circa 1330. (Watercolour by the author.)

29 (right). Piccotts End, Hertfordshire. The Baptism of Christ (detail of picture on page 29). An angel holds Christ's garments and John the Baptist wears a camel-skin tunic, the head of the camel hanging down near his feet. Circa 1500.

from Italian sources, and many were no doubt copied from title pages of books often via the Low Countries. Such painting may be seen at the Golden Cross, Cornmarket, Oxford. Great schemes like the painted frieze in the Bodleian Library and in Bishop Cousin's Library, Durham, seventeenth century, where there are portrait medallions of eminent figures in the various fields of academic learning, are unique. These portraits (over two hundred at Oxford) were copied from books containing collections of engraved portraits of worthies.

The remarkable building at Piccotts End, Hertfordshire, has paintings of about 1500 in one room and of Elizabethan date in another. This house is thought to have been in early times a hostel for pilgrims between Ashridge, where there was a famous relic of the Holy Blood, and St Albans, shrine of the protomartyr.

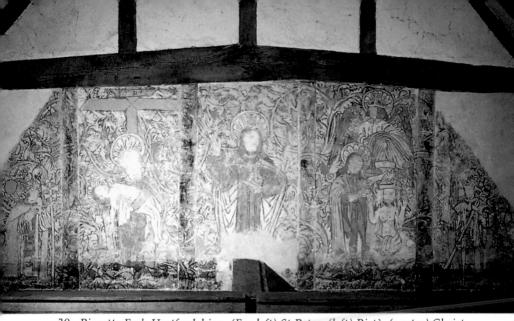

30. Piccotts End, Hertfordshire. (Far left) St Peter, (left) Pietà, (centre) Christ in Majesty, (right) the Baptism of Christ and (far right) St Clement. Circa 1500.

31. Longthorpe Tower, Cambridgeshire. Upper part of arched recess in west wall: St Anthony Abbot praying in the wilderness, with an acolyte making a basket. On the surrounding arch appear the Labours of the Months. Circa 1330. (Watercolour by the author.)

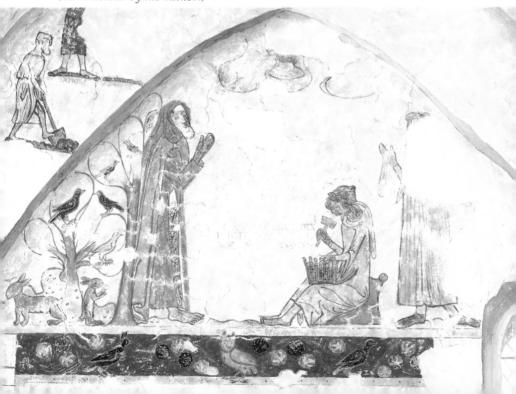

WHERE TO LOOK FOR PAINTINGS

In general terms, any church which retains its ancient plaster, heavily coated with limewash, may have wall paintings. The top layers will be of post-Reformation texts, concealing earlier, medieval work beneath. A specialist should always be called in before any redecoration or structural work involving disturbance of such wall surfaces is begun. It is perfectly easy to make tests and discover whether there are any remains of ancient painting present.

Only two or three subjects occur with any regularity in the same places. These include the Doom or Last Judgement above the chancel arch (though there are many exceptions to this); St Christopher is almost always found near or over a doorway or on a length of wall opposite the main entrance. Many churches have more than one St Christopher, repainted sometimes on opposite walls as the side of entrance was changed, or structural alterations made a change necessary (Poughill, Cornwall, and Glapthorn, Northamptonshire, each have two; Little Hampden, Buckinghamshire, has four). St George often accompanies St Christopher, either adjacent to or opposite him (Broughton and Padbury, Buckinghamshire).

There was always a Lady Chapel or Lady Altar at the east end of one of the aisles, and paintings connected with the Life of the Virgin may be found here (Chalfont St Giles, Buckinghamshire, and many others). Window splays are a favourite place for painting single figures of saints or single scenes (Little Kimble, Buckinghamshire; Frindsbury and West Kingsdown, Kent; Chalgrove, Oxfordshire; St John's, Winchester; Hailes, Gloucestershire; et cetera).

If the position and dedication of ancient altars or chantries in a church are known, it can almost certainly be assumed that paintings connected with that saint will have existed. (For a discussion of the whole question of subject matter, see below.)

If anyone wishes to see what an untouched church looks like, that is obviously covered with wall paintings of half a dozen periods, some appearing through layers of limewash, they should visit Inglesham in north Wiltshire, near Lechlade. This church was a favourite with William Morris, who lived at Kelmscott not far away. It is due to his efforts that no heavy-handed Victorian restoration ever took place there.

Patience is necessary in the understanding of fragmentary paintings, and the preservation of every scrap possible is vital. The student must

Where to look for paintings

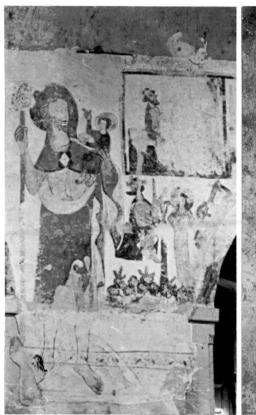

32 (left). Little Missenden, Buckinghamshire. North wall of nave: St Christopher and the Life of St Catherine, showing the wheel breaking asunder and the flying pieces hitting and killing the pagans who had tortured her. Circa 1300. (The scroll border is earlier.)

33 (right). Little Hampden, Buckinghamshire. St Christopher, reputedly the earliest known wall painting of this saint in Britain.

get his or her eye in. Every piece may provide important evidence and information when we have lost so much. Treat them like the small, individual pieces of a great jigsaw puzzle, in themselves meaningless or difficult to interpret. But you do not throw the pieces away on this account, or the whole picture will never be completed.

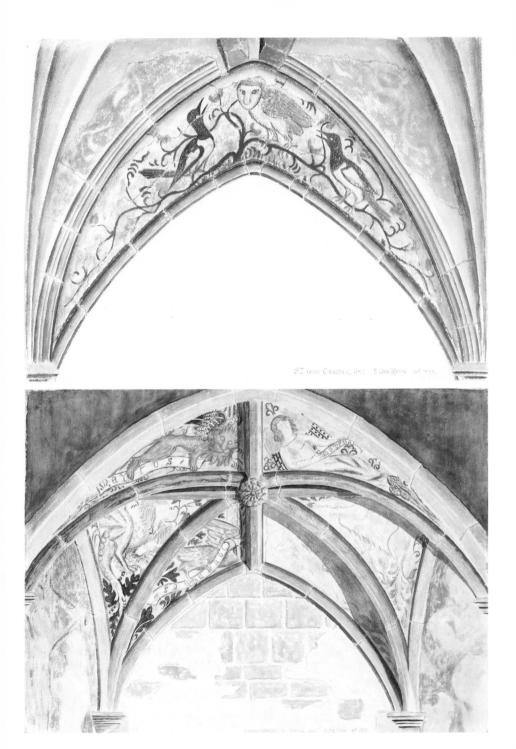

FACING PAGE: St Davids Cathedral, Dyfed. (Watercolours by the author.)

34 (top). An owl and two magpies beneath Bishop Gower's rood screen: idle chatterers mocking wisdom. Circa 1330.

35 (bottom). Roof vault with symbols of the four evangelists.

THIS PAGE:
36 (right). Stoke Orchard,
Gloucestershire. Window splay,
north wall of nave, north-east
window: Life of St James the
Great. (Left) Led to execution
by Josias, he meets a paralytic,
whom he heals. (Right) St James
is scourged. 1180-1200.
(Watercolour by the author.)

37 (below). Coombes, West Sussex. The lion symbol of St Mark, turning to face a central figure of Christ in majesty. Early twelfth century. (Watercolour by the author.)

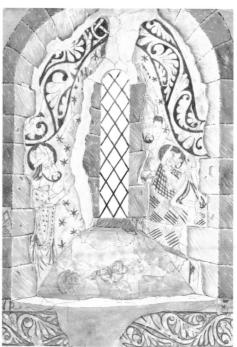

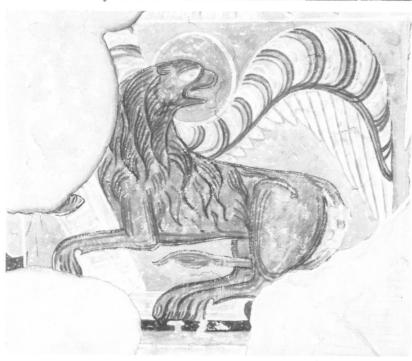

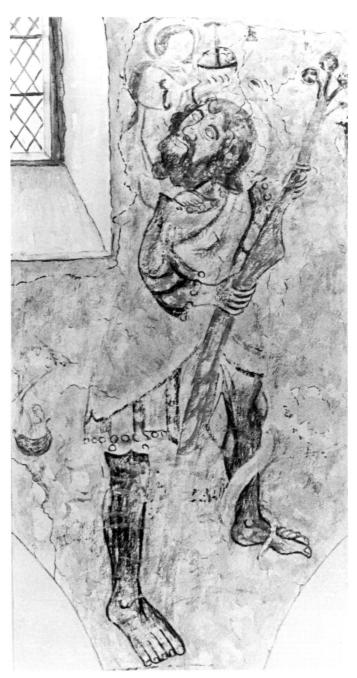

38. Llantwit Major, South Glamorgan. St Christopher and the Holy Child. Late fourteenth century. (Watercolour by the author.)

THE SUBJECT MATTER OF MEDIEVAL WALL PAINTINGS

At first sight, it might seem that the range and variety of the subjects and themes met with in English medieval wall painting were almost limitless. But careful analysis suggests that this is not really so and that the artists were working within a fairly limited, stereotyped framework.

The subject matter can therefore be roughly grouped under five main headings, which it will be useful to consider in detail. These are: (1) purely decorative schemes, either on their own, or in association with figure subjects; (2) the Bible story, Old and New Testaments; (3) single figures of saints, apostles, martyrs, et cetera; (4) lives of the saints in a number of scenes; (5) moralities, or moral and didactic or allegorical themes usually containing warnings against particular sins or modes of life. In other words, Christianity was brought down to earth, brought up to date and interpreted in terms of everyday life.

(1) DECORATIVE SCHEMES

It was not always possible or even desirable to have all the wall surfaces covered with figure subjects, and so a great deal of purely ornamental painting is found. Rough rubble or stone surfaces, and even good, finely jointed ashlar, were never left exposed. They were deemed unfinished and unworthy. Plaster was carried right over the window and door reveals, or the stonework was limewashed. The most fearful damage was done and endless wall paintings were destroyed by the Victorian practice of stripping plaster to reveal rough walling that was never meant to be seen. This point cannot be too much emphasised. In 1968 evidence was found in excavations at York Minster of exterior stone surfaces plastered and lined out with thick, painted imitation jointing.

The most common painted wall treatment was the masonry pattern, or imitation stone joint. This, with variations such as double or single vertical or horizontal joint-lines, and ornament in the blocks themselves, like roses, scrolls and various flowers and tendrils, is found from the twelfth to the fourteenth centuries. The earlier work is usually simpler. It can be found over large parts of the twelfth-century work at St Albans Cathedral. Even such an important building as the Chapter House at Christ Church Cathedral, Oxford, only had figures in roundels in the centre of the vault; all the rest was covered by a very simple single-line masonry pattern, with a little scrollwork of thirteenth-century date. The

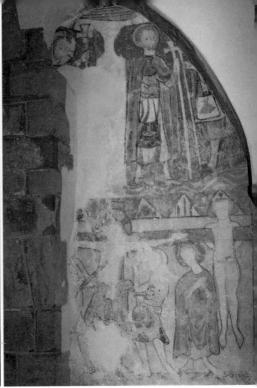

39 (above left). Hardham, West Sussex. East face of chancel arch: Adam and Eve and the serpent appear above Adam and Eve bathing. Circa 1100.

40 (above right). Wisborough Green, West Sussex. A head of Christ and a cross with, possibly, St James of Compostella greeting pilgrims; below is a Crucifixion with the miracle of Longinus. The iconography is unusual: Christ wears a crown and the robber is on the same cross member. Early thirteenth century.

41 (below). Peakirk, Cambridgeshire. Scheme of painting on the north wall of the nave and the north aisle: the Passion cycle, St Christopher and in the aisle the Three Living and Three Dead. Fourteenth century. (Watercolour by the author.)

THE SUBJECT MATTER: DECORATIVE SCHEMES

chancel at Haddenham, Buckinghamshire, had a complete masonry pattern scheme. Duntisbourne Rouse in Gloucestershire had a similar scheme. The earlier work at East Wellow, Hampshire, is all masonry pattern, with considerable variety; and some 'stoning and roses', as it is often called, can be found in an enormous number of churches.

The scroll was another important decorative motif; and its evolution and development are valuable in dating. It occurs from the beginning of the twelfth century to the end of the fourteenth, both on its own as a dado or for outlining windows, doors and arches, as well as for framing or dividing figure subjects. Some of the earlier scrolls are to be found at Clayton, West Sussex, and Plumpton, East Sussex. Risby in Suffolk has subjects on the north wall divided by a repeated scroll, as well as in window splays (thirteenth century). At Stoke Orchard, Gloucestershire, the scrolls are unique, the upper differing from the lower, and each changing its character every few feet. Scrollwork is combined with masonry pattern at Bledlow and Weston Turville, Buckinghamshire, in the nave arcade spandrels.

Arches were often picked out in blocks of alternating different colours — red, yellow, black and white — and were sometimes stippled over in an attempt to represent marble. The chevron was another popular ornamental feature.

42 (left). Llantwit Major, South Glamorgan. Tessellated pattern (symbols of the Passion above). (Watercolour by the author.)

43 (right). Coombes, West Sussex. Imitation masonry pattern in the chancel. The double lines suggest a late date. Some, but not all, of the blocks are filled with ornament. (Watercolour by the author.)

Backgrounds were often diapered with small decorative devices, such as roses (cinquefoils, sexfoils, et cetera), stars (Stoke Orchard, Gloucestershire), crosses (Chalfont St Giles, Buckinghamshire), fleurs-de-lis, et cetera. These developed into more elaborate motifs, sometimes clearly painted with a stencil, which became virtually a brocade pattern, and are generally confined to the very late fourteenth and the whole of the fifteenth century. They most often accompany St Christopher and other figure subjects (Corby Glen, Lincolnshire).

Heraldry was often used not only for its decorative value but as a reference or tribute to lords of the manor, local great families or benefactors of the church, and as such is very valuable historically. Elaborate schemes of this sort can be seen at Hailes (Gloucestershire), Chalgrave (Bedfordshire) and Ampney Crucis (Gloucestershire) as well as in many isolated examples.

(2) THE BIBLE STORY

This is by far the most extensive and important group of paintings, for obvious reasons. The first essential in the teaching and upholding of Christianity is the basis of its faith as contained in the Bible, both Old and New Testaments.

For some reason in England the Old Testament is found less often than the New and it is confined to comparatively few scenes. At Hardham, West Sussex, there is a fairly extensive series with the Temptation, Fall, Expulsion and various rather unusual versions of the Labours of Adam and Eve. At Chalfont St Giles, Buckinghamshire, we find part of a Creation scene (animals and birds) and the Fall and Expulsion from Eden, all with diapered backgrounds and scrollwork (first half of the fourteenth century). At Bledlow, Buckinghamshire, Adam digs and Eve spins with a distaff (also fourteenth century but later). Cain and Abel appear on window splays at West Kingsdown, Kent. We know from the royal household accounts of the time of Henry III that the history of the Maccabees was among the many subjects represented in the Painted Chamber at the Old Palace of Westminster (destroyed by fire in 1834). For some reason the major prophets and some of the great stories of the Old Testament, like Moses, Noah's Ark, the Tower of Babel, the Children of Israel and the Red Sea, David and Goliath, Nebuchadnezzar, Joseph, Daniel in the Lions' Den, the Burning Fiery Furnace, the Walls of Jericho, Samson and so on, seem to find little place in English wall painting, though frequent on the Continent. Such subjects are found in English

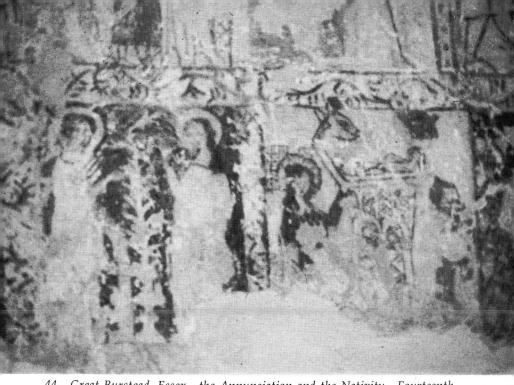

44. Great Burstead, Essex. the Annunciation and the Nativity. Fourteenth century.

45. West Chiltington, West Sussex. Part of a Passion cycle. Thirteenth century.

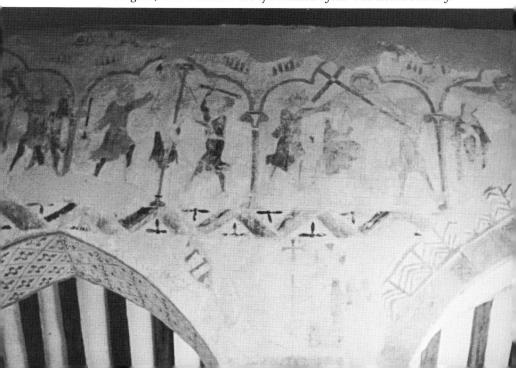

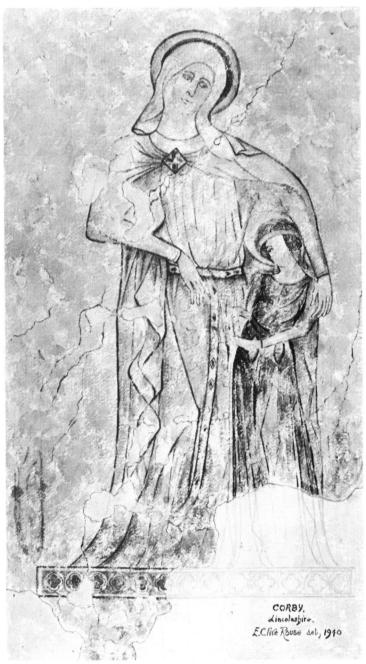

46. Corby Glen, Lincolnshire. St Anne and the Virgin Mary. Fourteenth century. (Watercolour by the author.)

THE SUBJECT MATTER: THE BIBLE STORY

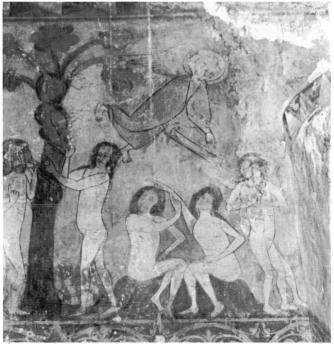

47. Easby, North Yorkshire. Scenes from the story of Adam and Eve: the Temptation, the Fall and the Expulsion from the Garden. Mid thirteenth century.

manuscripts and in carving, particularly Samson and the Lion.

The New Testament bulks very large, whether there are single figures of Christ, the Virgin and so on, or individual scenes like the Nativity, Baptism, Crucifixion, Resurrection or Ascension; or series of cycles of the Nativity, Infancy, Life of Christ or Passion, the first and last being the most frequent. The ordinary visitor must not be put off by the inclusion of some rather strange and unusual scenes in Nativity series, particularly in some of the very early paintings like those at Hardham and Coombes in West Sussex, where the Angel's appearance to Joseph in his dreams is shown. The Fall of the Idols on the Flight into Egypt, and the Worship of the Animals at the Manger, mostly culled from various versions of the apocryphal gospels, also appear. There are very many fine examples of both individual scenes and Nativity or Passion cycles. A few may be instanced: the series of Crucifixions and scenes concerning the Virgin (Annunciation, Virgin and Child, Coronation) on the west faces of the

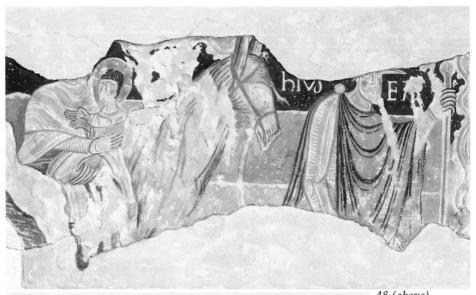

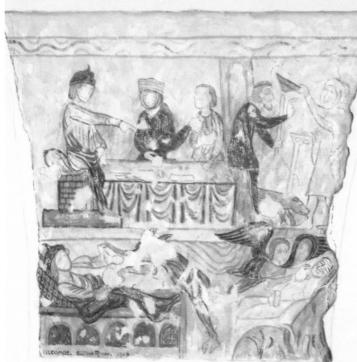

48 (above).
Coombes, West
Sussex. North
wall, east end: the
Flight into Egypt.
Twelfth century.
(Watercolour by
the author.)

49. Ulcombe, Kent. The parable of Dives and Lazarus. Late thirteenth century. (Watercolour by the author.)

THE SUBJECT MATTER: THE BIBLE STORY

50. Peakirk, Cambridgeshire. Christ washing the disciples' feet. (Watercolour by the author.)

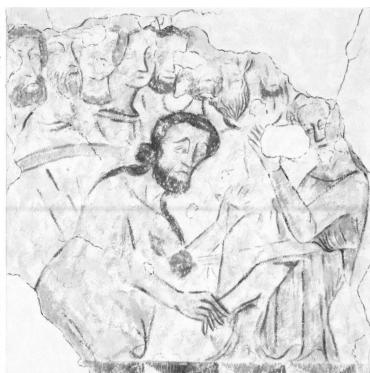

51 (below).
Padbury,
Buckinghamshire.
The miracle of St
Edmund's head
and the wolf.
Fourteenth
century.
(Watercolour by
the author.)

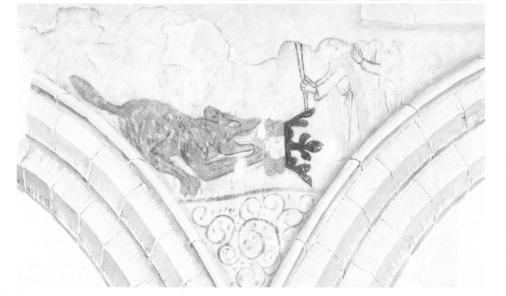

great Norman piers on the north side of the nave in St Albans Cathedral; Peakirk, Cambridgeshire; Pickering, North Yorkshire; West Chiltington, West Sussex; Fairstead, Essex; Winchester, Hampshire (Holy Sepulchre Chapel). One of the best series of Passion scenes and the Life of the Virgin is at Croughton, Northamptonshire (fourteenth century); another is in the chancel at Chalgrove, Oxfordshire.

Another subject frequently found is the Tree of Jesse or the ancestry of Christ — a literal tree springing from Jesse's side, kings and prophets in the branches, and the Virgin and Child at the top.

It is curious that the miracles and parables appear very seldom. The Marriage at Cana (the turning of water into wine) and the Raising of Lazarus and of Jairus's Daughter (Copford, Essex) are amongst the few miracles represented. While of the parables, Dives and Pauper (or Dives and Lazarus, as at Ulcombe, Kent) is one of the few examples. The Good Samaritan and the Prodigal Son occur, oddly enough, in post-Reformation domestic paintings.

52 (left). Bradwell Abbey, Buckinghamshire. St Mary's Chapel, left-hand window: St Anne teaching the Virgin. The stencilled M, for Mary, is found throughout the chapel. Late fourteenth century.

53 (right). Bradwell Abbey, Buckinghamshire. St Mary's Chapel, right-hand window: the Annunciation. Late fourteenth century.

THE SUBJECT MATTER: SINGLE FIGURES OF SAINTS

54. Whitcombe, Dorset. St Christopher. Early fifteenth century.

(3) SINGLE FIGURES OF SAINTS

Single figures of apostles, saints and martyrs are of very frequent occurrence; and to this group can be added representations of single scenes in their lives (St Christopher carrying the Christ Child across the stream; St George killing the dragon; St Catherine and the spiked wheel; St Margaret emerging from the dragon).

It should be clearly understood that these figures were not selected on any basis of decorative or pictorial value, or because of some current fashion. In pre-Reformation England the attributes of particular saints were well known, and they were invoked for particular things and on particular occasions. St George, the patron saint of England, was a type of manly Christian virtue and chivalry, and when you saw his picture on the church wall you were reminded of these qualities and said your intercession for your husband who was on the Crusades, or for your son or your brother who was fighting in the French wars.

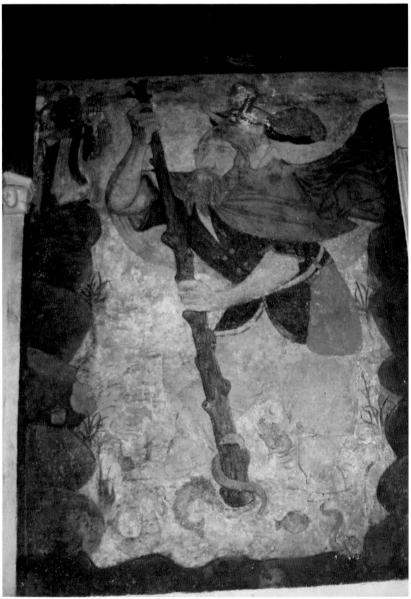

55. Hayes, Middlesex. St Christopher. Fifteenth century.

THE SUBJECT MATTER: SINGLE FIGURES OF SAINTS

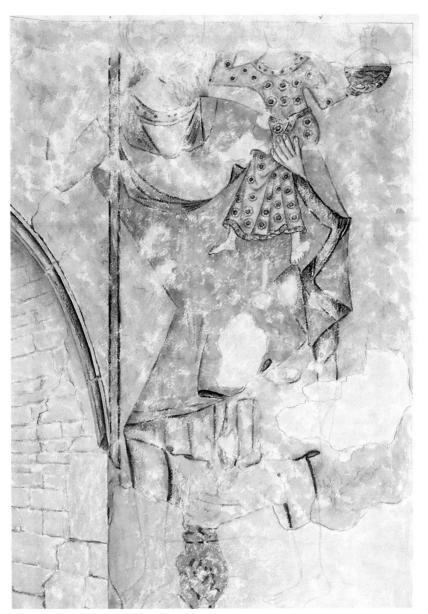

 $56.\ Corby\ Glen,\ Lincolnshire.\ St\ Christopher.\ 1300-20.$ (Watercolour by the author.)

St Christopher, the patron saint of travellers, was invoked for those setting out on pilgrimage, or on a journey, which in medieval England could be difficult and even dangerous. But he was more than this: his story teaches salvation through service; the windmills, churches, houses, fishermen and boats introduced into the scene served as reminders that his legend was applicable in the everyday world. This can be well seen at Baunton, Gloucestershire, and Shorwell in the Isle of Wight. The introduction of a mermaid into the picture often puzzles people. The mermaid comes straight from the Bestiaries — those collections of beasts, real and imaginary, having a religious or moral significance, and of which there are many examples in manuscripts. The mermaid was an evil creature, a siren to lure men to destruction, and her presence in St Christopher paintings is intended to suggest temptation and distraction of the saint from his task. (The pelican feeding her young from her own breast and the phoenix rising from the flames, also found in the Bestiaries, are both Christian symbols, of the Crucifixion and Eucharist and the Resurrection, and may be seen at Belchamp Walter, Essex.)

St Catherine was an immensely popular figure and as patron saint of clerks and of learning was much venerated in an age when knowledge

was power and in the hands of comparatively few.

St Margaret was invoked by women in childbirth. St Nicholas was the patron saint of children (Santa Claus) and of sailors. St Anthony Abbot was venerated especially by basket-makers, and his aid was sought in cases of 'St Anthony's fire' (erysipelas). At Longthorpe Tower near Peterborough he is shown in the wilderness amongst birds, trees and rabbits during his vision of angels alternately working (making baskets) and praying, and who say to him 'Do this and you shall have everlasting life'.

The presence of other single figures of saints is probably to be accounted for by individual choice or because the person responsible for commissioning the painting had a particular devotion to a particular saint. Thus we find a wide variety: St Martin dividing his cloak with the beggar (Nassington, Northamptonshire; Chalgrave, Bedfordshire), St Clare, St Francis, St Bernard (Little Kimble, Buckinghamshire), St Eligius or St Eloy (the patron saint of smiths, blacksmiths in particular). To these must be added single figures of the apostles and evangelists, often in association with the dedication of a church. The range is thus very wide, and the matter of identification by their symbols or actions a continual interest.

57 (above). Little Kimble, Buckinghamshire. In this church, dedicated to All Saints, a total of eleven different saints are identifiable. Shown here are the burial of St Catherine (left) and St Bernard (right). Early fourteenth century.

58 (below left). Nether Wallop, Hampshire. South arcade of nave: St George and the dragon with the king and queen looking on. Fifteenth century.

59 (below right). Little Kimble, Buckinghamshire. St George, represented, unusually, as standing, not mounted. Early fourteenth century.

(4) LIVES OF THE SAINTS

This class of painting follows on naturally from the last, but instead of a single figure or a single scene from a saint's life (like St Martin dividing his cloak with the beggar; St George slaying the dragon; St Nicholas rescuing the three boys from the pickle tub; St Anne teaching the Virgin to read, and so on) we have a series of scenes forming a longer or shorter version of that saint's 'history'. This obviously gave greater scope to the artist, to the parish priest to expound a good story, and to the congregation for interest as well as devotion.

The scenes were sometimes in two or more tiers and were treated in a manner not unlike the modern strip cartoon — if one may use such an

60 (left). Pickering, North Yorkshire. North arcade: (above) the Martyrdom of St Thomas à Becket; (below) the Martyrdom of St Edmund. Fifteenth century.
61 (right). Wareham, Dorset. The story of St Martin: (above) St Martin's encounter with the naked beggar and (below) St Martin's vision of Christ wearing the half of his cloak which he gave to the beggar. These are amongst the earliest wall paintings in Britain. Twelfth century.

62. Stoke Orchard, Gloucestershire. Part of a Life of St James the Great and his encounter with Hermogenes the Enchanter, with unique decorative borders. Thirteenth century (?). (Watercolour by the author.)

analogy. Some very early examples (the Sussex group of Clayton, Plumpton, Hardham and Coombes) have the scenes divided by fantastic architectural motifs. Others run on without vertical divisions, being bordered at top and bottom in the manner of the Bayeux Tapestry, or the tiers are divided by dado bands or scrolls (Risby, Suffolk). These are sometimes very difficult to sort out, especially when the paintings are fragmentary, as they so often are. Often the clue is to be found in the fact that the figure at the end of one scene and that at the beginning of the next have their backs to each other, the interest or action of each scene being in the centre, with the main participants facing each other (as at Stoke Orchard, Gloucestershire).

In other cases the scenes are contained within arches (West Chiltington, West Sussex) or are divided by simple vertical lines or frames as at Sporle (Norfolk), Little Missenden (Buckinghamshire) and Tarrant Crawford (Dorset).

63. Little Kimble, Buckinghamshire. The Martyrdom of St Margaret. She is hung up by the hair (centre) and beheaded (right). Early fourteenth century.

Much of course depended on the space (or the money) available in deciding the number of scenes, incidents or miracles to be shown. Some, like the Life of St Catherine at Sporle, Norfolk, were extensive; in this case some 27 scenes are included. Others were a mere epitome of the main events, like the 'Life' of St John the Baptist at Chalfont St Giles, Buckinghamshire, where only three scenes appear, and two of those are telescoped into one.

Probably the most extensive series, and certainly the best artistically and one of the few that are documented, is the Life and Miracles of the Virgin, the scenes divided by figures of female saints in elaborately painted representations of canopied niches, on the walls of Eton College Chapel, Berkshire. The College accounts show that they were painted by one Gilbert and by William Baker and his assistant(s) between 1478 and 1482. Their life was a short one; for in 1560 the College barber was paid 6s 8d (half a mark) to obliterate them with whitewash. Thus they remained for nearly three hundred years, until the Prince Consort, visiting the chapel one day, found workmen busily engaged in scraping them off the walls. He was able to halt the work, but not before almost the whole of the upper row of scenes on each side had been destroyed. They were then concealed behind the sham Gothic stall canopies put up by George Street, until they were revealed once more by Professor Tristram under the inspiration of Provost M. R. James, probably the greatest medieval scholar of his generation. A similar series is in the Lady Chapel at Winchester Cathedral.

THE SUBJECT MATTER: LIVES OF THE SAINTS

The cult of the Virgin was enormous in the middle ages, and representations of her life and miracles must have occurred in most churches, especially in connection with the Lady Altar. These range from the humblest works like those at Chalfont St Giles and Bradwell Abbey, Buckinghamshire, through the fine series at Croughton, Northamptonshire, to the supreme examples just mentioned above, and including the exquisite Virgin and Child in the chapel of the Bishop's Palace at Chichester. It is almost solely in scenes like this, and the Weighing of Souls, that any tenderness or humanity is allowed to creep in.

Next in popularity are probably St Catherine and St Margaret (as at Battle, East Sussex) and St Thomas of Canterbury (Thomas à Becket), who became almost a national saint, as did St Edmund. Then there are those 'local' saints whose legends are less familiar and consequently more difficult to identify, like St Swithin of Winchester, whose restoration, intact, of a basket of eggs, broken by hooligans, to a poor woman is shown at Corhampton, Hampshire.

64. Battle, East Sussex. The scheme on the north wall of the nave depicting the Life of St Margaret of Antioch. Thirteenth to fourteenth century.

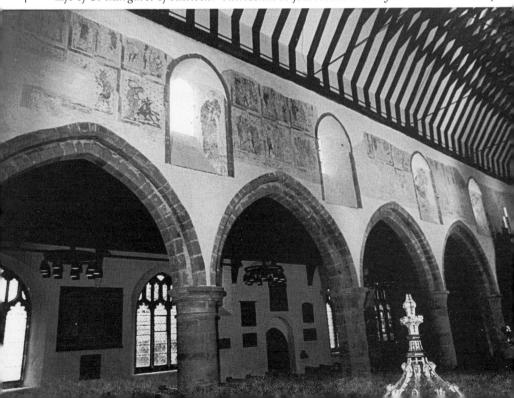

Sources. It will obviously be asked what were the literary sources for the different versions of the lives and miracles of the saints. But in this small book it is not possible to enter into an academic discussion of medieval literature or manuscript sources. That is one of the many facets of this whole subject that the student must follow up for himself. There were many such sources available to the priest and artist, like the Libelli or small lives of various saints and martyrs, or Vincent de Beauvais' Speculum Historiale and others. But probably the most familiar and most used was the compilation known as the Golden Legend or Lives of the Saints — the Legenda Aurea — of Jacobus de Voragine, Archbishop of Genoa, about the middle of the thirteenth century. He in turn drew on earlier sources such as St Jerome, Eusebius and others, and the work in manuscript form soon spread all over Europe. It contains accounts of lives or references to some 160 or 170 saints, apostles, martyrs or festivals of the

65. Battle, East Sussex. Panels from the Life of St Margaret of Antioch on the north wall of the nave. The scenes include (above left) St Margaret pushed into prison — a typical representation of a prison in this period — on the orders of the wicked Provost, who is identified as evil by the fact that his legs are crossed, and (below centre) St Margaret hung up by the hair and beaten. The men who torment her wear strange hats and are grotesque in face and body. Thirteenth to fourteenth century.

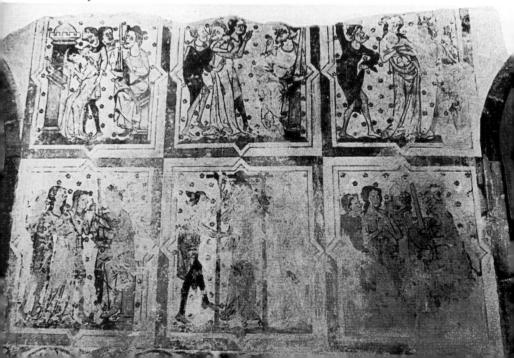

THE SUBJECT MATTER: LIVES OF THE SAINTS

Church. Today we are familiar with it in the superb English of Caxton's translation of 1483. It is interesting that, even at that date, doubts were beginning to creep in as to the literal authenticity of some of the fantastic happenings recorded. For instance, in the Life of St Margaret of Antioch, she asks that, while in prison, the devil that is tempting her to take the easy way out, forsake her Christianity and yield to the wicked Provost's demands should be shown to her in bodily form. Caxton continues, 'And then appeared a horrible dragon and assailed her and it is said that he swallowed her into his belly, she making the sign of the Cross. And the belly brake asunder, and so she issued out all whole and sound.' And then the charming aside: 'This swallowing and breaking of the belly of the dragon is said that it is apocryphal.' The scene perhaps accounts for St Margaret being invoked by women in childbirth; and it is one most frequently represented (Tarrant Crawford, Dorset; Piccotts End, Hertfordshire; Battle, East Sussex).

Other and much older and more obscure sources were used for the remarkable Life of St James of Compostella (St James the Great, the apostle) at Stoke Orchard, Gloucestershire, for the paintings were executed before the *Golden Legend* was compiled or at least became current. There are some 28 scenes surviving, and there were originally many more. Some do not occur in the *Golden Legend* at all and others appear out of order. Sources thought to have been used are the pseudo-Abdias and the compilation of Pope Callixtus II.

In all the foregoing subjects, the Nativity and Passion cycles in particular, a very close link is observable between them, with their episodic treatment, and the medieval religious drama or pageants, performed at festivals on moving wagon stages. Scripts of some of the York, Coventry and Wakefield cycles might well have inspired the mode of presentation of many scenes, like the Nativity set shown by life-size single figures at Corby Glen, Lincolnshire. There King Herod, cross-legged on his throne, might have stepped straight out of the Coventry Shearmen and Tailors' play.

Where can you have a more greater succor Than to behold my person that is so gay, My falchion, and my fashion with my gorgeous array?

Dr Hildburgh has also noted close affinities with the alabasters and the Passion and Nativity plays.

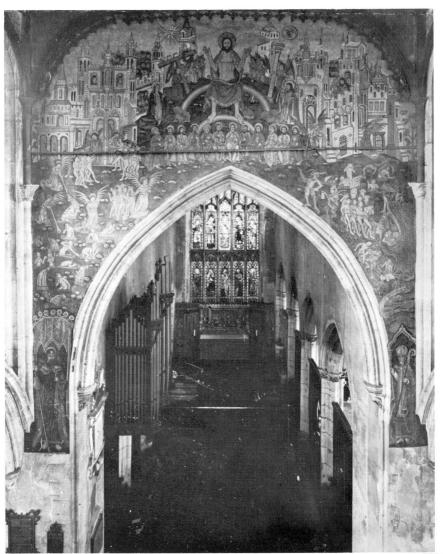

66. Salisbury, Wiltshire. The repainted Doom in St Thomas's church. Late fifteenth century.

THE SUBJECT MATTER: MORALITIES

(5) MORALITIES

The last group into which the subject matter to be found painted on English church walls has been divided is the Morality or Warning. This group is in many ways the most interesting of all, providing as it does a much more human element and a closer insight into the medieval mind, its processes of thought and its teaching methods. The Moralities are moreover more closely based on contemporary literature and teaching.

THE DOOM. In this class have been placed the great paintings of the Doom or Last Judgement without which no church was complete and which were usually situated (though space sometimes dictated otherwise) in the most prominent position, fully facing the congregation over the chancel arch. The subject is a biblical one, but in the paintings it becomes a great allegory, literally represented, and that is why it is included here. Although details vary, the general composition is constant. It is treated as a great drama in a number of scenes.

Christ is in the centre, judging the quick and the dead. He is seated on a rainbow whose ends emerge from conventional clouds. He is robed to display the five wounds, and He blesses with one hand and holds up the open palm in judgement. His feet are on a sphere, divided so as to denote dominion over the elements of earth, air and water. Scrolls often bear the words, to those on His right hand (the north or left side from the spectator's point of view), 'Come ye blessed of my Father, and inherit your kingdom ...' To those on the other side are addressed the ominous words 'Go ye evil-doers into eternal fire'. Angels usually bear symbols of the Passion. Groups of the heavenly host often flank the central figure and are led by the Virgin and John the Baptist, with the apostles and evangelists, while other angels blow a literal Last Trump.

Lower down is the General Resurrection, with souls (always by convention represented as small naked figures) rising from graves or coffins, and awaiting judgement. On the north side (supposing the painting to be on the east wall) is represented the Heavenly Jerusalem — a collection of battlemented, gated and towered buildings with St Peter and angels receiving the Blessed at the gate. On the south side are the torments of the damned in Hell, where the artist really let himself go, with souls dragged off by a chain, a great gaping mouth, cauldrons, flames, demons, bellows, pitchforks and horrors unimaginable. Often the Seven Deadly Sins are shown in Hell, or on their way to it. What the effect of this was on simple minds may well be guessed. Something of this is expressed in

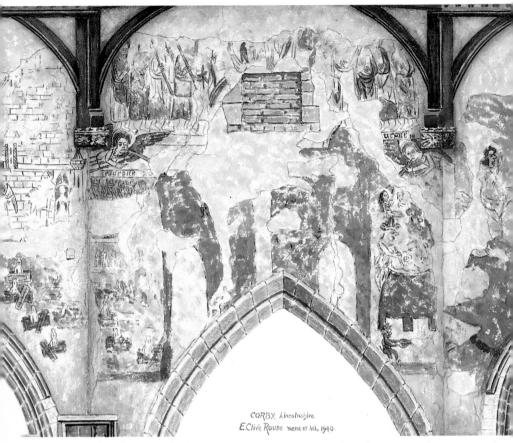

67. Corby Glen, Lincolnshire. The Last Judgement. Fifteenth century. (Water-colour by the author.)

one of François Villon's *Ballades*, at his mother's request to invoke Our Lady (late fifteenth century):

A pitiful poor woman, shrunk and old I am, and nothing learn'd in letter lore. Within my parish-cloister I behold A painted Heaven where lutes and harps adore And eke an Hell whose damned souls seethe full sore: One bringeth fear, the other joy to me.

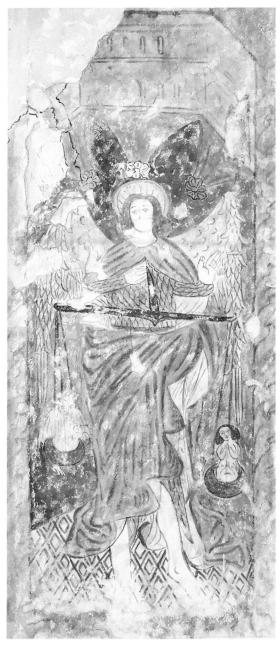

68. Stanion, Northamptonshire. St Michael with the scales of justice, weighing a soul (right) against its sins (left). (Watercolour by the author.)

Fear and joy, good and evil, life and death — this is really the whole burden of medieval religious painting. Examples of Doom paintings are too numerous to mention: but the great composition over the chancel arch at St Thomas's church, Salisbury, though largely repainted in the nineteenth century, gives a very good idea of the overwhelming awe-someness of the whole subject.

Everyone who has ever noticed a wall painting at all is probably familiar with the strange subject filling the whole west wall at Chaldon church, Surrey. This is sometimes erroneously called a Doom but should more properly be called the Ladder of Salvation, a kind of schematic representation of the Redemption. Its date is the end of the twelfth century, though touched up, and the origins of its theme must date from Byzantine sources. Included in the composition are the Harrowing of Hell or Descent into Limbo or Purgatory; Our Lord taking Adam and Eve by the hand; the Tree of Knowledge; the Torments of Hell; the Seven Deadly Sins; and the Weighing of Souls.

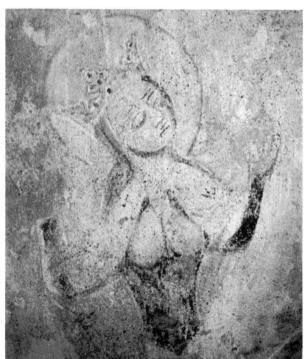

69. North Cove, Suffolk. Part of a Last Judgement scene on the south chancel wall: the Virgin on Christ's right hand with breasts bared as a form of supplication. Fourteenth century.

THE SUBJECT MATTER: MORALITIES

THE WEIGHING OF SOULS. The Weighing of Souls was sometimes included as part of the Doom, but also quite frequently treated separately. It is all picture language for the idea that at the Last Day one's good deeds will be weighed in the balance against one's bad deeds — a belief not peculiar to the Christian religion, but found also in Egypt and in classical mythology. This is shown literally, with St Michael holding an enormous pair of scales. The Devil tries to weigh one side down, urging your sins; while on the other the Virgin intercedes by touching the beam or placing the beads of her rosary in the other pan and so weighing it down in favour of the soul, her compassion being underlined by the action. In some cases (Corby Glen, Lincolnshire; Broughton and Little Hampden, Buckinghamshire) she is also shown as sheltering or protecting souls under the folds of her cloak, an idea of thirteenth-century French Cistercian origin, where she is called La Vierge Manteau Protecteur or La Vierge de Miséricorde. It is of interest that only in such scenes connected with the Virgin is any tenderness or humanity allowed to creep in. The rest is stern, crude stuff. The times were crude, and if you wished to impress crude and simple people, crude methods had to be employed to bring home the enormity of sin, and its penalties, the rewards of the just, and the uncertainty of life.

GOOD AND EVIL. The eternal struggle between good and evil is indeed the paramount theme of most medieval painting, and especially in this group of the Moralities. The Seven Deadly Sins and the Seven Corporal Works of Mercy gave the parish priest the opportunity to expand on this subject. Pride, Envy, Anger, Lust, Covetousness, Sloth and Gluttony on the one hand are balanced by Receiving Strangers, Clothing the Naked, Feeding the Hungry, Giving Drink to the Thirsty, Visiting the Sick, Visiting Prisoners and Burying the Dead, as in the text of St Matthew, chapter 25. At Linkinhorne in Cornwall, the Works of Mercy surround a figure of Christ Himself.

The methods of representation are very varied. In early examples (twelfth century) the struggle is shown as a combat between Virtues and Vices (the Psychomachia or battle of the soul). These are usually armed figures, sometimes on horseback, as at Copford (Essex), Claverley (Shropshire) and Pyrford (Surrey). Later, various diagrammatic forms were used. Diagrams were beloved of the intelligentsia in the middle ages, as may be seen in many encyclopaedic manuscripts like *Queen Mary's Psalter* and the *Arundel Psalter*. The tree was a favourite motif, since it has a cycle of growth, leaf, blossom, waning and apparent death

70. Corby Glen, Lincolnshire. A warning to blasphemers: the Virgin holding the dismembered body of Christ, surrounded by youths swearing, and each tempted by a devil. Fifteenth century. (Watercolour by the author.)

71. Tarrant Crawford, Dorset. The Three Living and the Three Dead: the three kings. (Watercolour by the author.)

72. Breage, Cornwall. (Left) St Christopher and (right) a warning to sabbath-breakers which teaches that the tools of various trades, if used on a Sunday, inflict injuries on the body of Christ. Late fifteenth century.

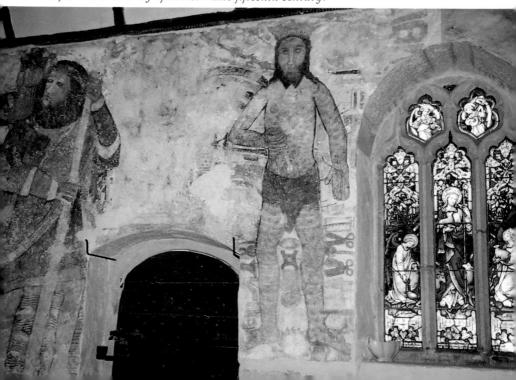

73. Arundel, West Sussex. Detail of the Seven Deadly Sins: the head of the sin of Pride at the centre with the other sins attached to, or emanating from it.

or inertia, only to start again in the spring. Chaucer used the simile for the Seven Sins in his Parson's Tale: the evil stock or trunk that has its roots in the sizzling cauldron of hell; the limbs, branches, twigs and buds representing other sins all stemming from the central stock of Pride. This treatment is shown at Ruislip, Middlesex. The wheel, another diagrammatic representation of continuous or recurrent movement, was another very popular form. There are Wheels of the Seven Sins, of the Virtues (Arundel, West Sussex), of Life Gloucestershire; (Kempley, Longthorpe, Cambridgeshire), of

74. Padbury, Buckinghamshire. The Seven Deadly Sins. (Watercolour by the author.)

THE SUBJECT MATTER: MORALITIES

Fortune (Rochester, Kent), of the Five Senses (Longthorpe) and so on. At Padbury, Buckinghamshire, the Wheel treatment is used for the Seven Sins. Pride and her six daughters or the Purging of Pride, where the central figure is speared by Death, is another version (Raunds, Northamptonshire: Little Horwood, Buckinghamshire, et cetera). The Sins and the Works of Mercy are shown in dragons' mouths and in roundels respectively on the west wall at Trotton, West Sussex, and there are many examples up and down England.

75 (above right). Ruislip, Middlesex. North arcade of nave: the Seven Deadly Sins. Fifteenth century.

76. Trotton, West Sussex. West wall: Christ in Judgement, with (left) the Seven Deadly Sins and (right) the Seven Corporal Works of Mercy — the good man surrounded by his good deeds. Fourteenth or fifteenth century.

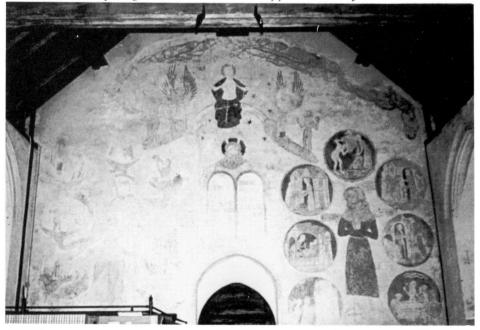

Warnings: The Three Living and the Three Dead. Many other moralities take the form of awful warnings against particular sins or bad habits. Of these, one of the most frequently met with is the warning of the transitory nature of earthly rank and riches, known as the Three Living and the Three Dead, or, since it seems to originate in a French late thirteenth-century manuscript, Les Trois Rois Vifs et les Trois Rois Morts. There is an almost contemporary English manuscript, the Psalter of Robert de Lisle, sometimes known as the Arundel Psalter, in the British Library, now thought to date in part from the end of the thirteenth century, which shows this subject and on which very many wall paintings must have been based. Three kings, sumptuously robed, one with hawk on wrist, encounter three grisly skeletons, and the following conversation takes place. The Kings: First: 'I am afeared.' Second: 'Lo! what I see.' Third: 'Me thinketh it be devils three.' The skeletons: First: 'I was well fair.' Second: 'Such shalt thou be.' Third: 'For God's love be warned by me.'

77. Tarrant Crawford, Dorset. The Three Living and the Three Dead: the three skeletons. (Watercolour by the author.)

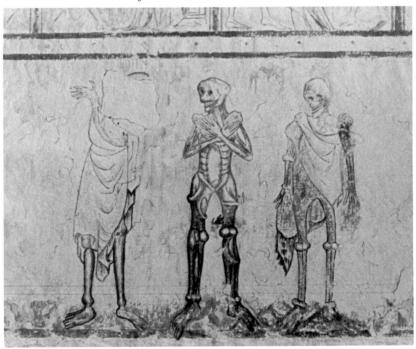

THE SUBJECT MATTER: MORALITIES

In other words, no matter how rich and important you may be, death will come, and perhaps sooner than you think. On the Continent, the kings are usually mounted, out hunting, but in England more often on foot. The subject is of very wide distribution and frequent occurrence — popular is perhaps hardly the word since various creepy-crawlies, toads, worms, moths and every symbol of decay and corruption are often introduced. It is found from Wensley in North Yorkshire to Charlwood in Surrey, from Tarrant Crawford in Dorset and Widford in Oxfordshire to Raunds (Northamptonshire), Longthorpe and Peakirk (Cambridgeshire) and Pickworth (Lincolnshire), with numerous fragmentary examples scattered all over England, especially in Norfolk and Suffolk. Later examples, following the fearful mortality of the Black Death (1348-9), seem to be the more numerous. It is an obvious counterpart to the Dance of Death or *Danse Macabre* which is so often found on the Continent.

Warning To Swearers. A subject occasionally found is that of a warning against the sin of blasphemy, or swearing by parts of Our Lord's body, apparently very prevalent in the fourteenth and fifteenth centuries. At Broughton, Buckinghamshire, and at Corby Glen, Lincolnshire, the Virgin is seated in the centre, holding the dismembered body of Christ, surrounded by fashionably dressed youths either holding parts of the body — bones, feet, heart — or with scrolls containing their oaths. In a window (now gone) at Heydon, Norfolk, they were swearing, 'By God's bones that was good ale', 'By God's heart I will go to town', 'By the feet of Christ I will beat you at the dice', and so on. This is referred to by Chaucer in the Pardoner's Tale:

... The cursed swearers:
'Tis grisly for to heare them sweare,
Our blissed Lorde's bodie they to-teare:
Them thoughte Jewes rent him not ynough.

At Corby Glen there is the added feature that each of seven youths is accompanied by a devil tempting him to the sin, and there are allusions to the Wounds of Christ and the Seven Deadly Sins — the whole subject a mass of symbolism. There is an obvious counterpart in the painting of the Seven Corporal Works of Mercy at Ruabon, Clwyd, where each good deed is inspired by an angel.

WARNING TO SABBATH-BREAKERS. Of much wider distribution is a strange representation of Christ, naked but for a loincloth, displaying the five wounds and often covered with drops of blood, surrounded by tools, implements and objects of every sort of trade and occupation. There was a group of five or six in Cornwall, but only Breage, Poundstock and St Just in Penwith survive. It is found at West Chiltington (West Sussex), Ampney St Mary (Gloucestershire), Hessett (Suffolk), Nether Wallop (Hampshire) and many other places. It has been the subject of much learned speculation and discussion in the past. It has been called the Christ of the Trades and the Consecration of Labour; Professor Tristram identified it as Christ as Piers Plowman (in allusion to passages in John Langland's work), and there have been other interpretations. A painting in the church of St Miniato outside Florence, showing this precise subject of Christ surrounded by tools touching Him, has an inscription beneath it which puts the matter beyond doubt. In translation it reads: 'Whoso does not keep holy the Sabbath Day and have devotion to Christ, God will consign him to everlasting damnation.' The teaching is clear, that by using the tools of your trade and ignoring Christ on His Sabbath Day, you not only inflict injury on the body of Christ, but condemn yourself to perdition.

WARNING AGAINST IDLE GOSSIP. A feature complained about (and preached against, as shown by Professor Owst in his *Preaching in Medieval England* and *Literature and Pulpit in Medieval England*) was the evil habit of people chattering and gossiping inside and about the church. Idle gossip and scandalmongering can have far-reaching disastrous effects; and this is shown by two paintings at Peakirk, Cambridgeshire, and Little Melton, Norfolk, where two women are hard at it, but on their shoulders stands a devil cramming their heads together and encouraging the evil practice.

There are a number of paintings which do not seem to fit into any particular category, but which clearly have an allegorical or moral significance and so may be considered here. At Swanbourne in Bucking-hamshire is a curious painting showing the states of the soul before and after death — angels and devils contending for the soul and so on, with long inscriptions. The lesson is clear, that if you have lived a thoroughly virtuous life, your place in heaven is assured; if you have been only moderately good there will be a struggle between the forces of good and evil for possession of your soul; but if you have led a thoroughly bad

THE SUBJECT MATTER: MORALITIES

existence on earth, then you are without hope destined for the nether regions. So far the literary source for this interesting painting has not been traced. But the origin of many others is to be found in such works as *The Desert of Religion*, the *Hortus Deliciarum* (or *Garden of Delights*), John Mirk's instructions to parish priests in his *Festial* and the poems of Langland, Chaucer and Lydgate.

Many strange birds, animals and creatures are often found on church walls, as at Hailes, Gloucestershire, mostly inspired by the *Bestiaries*, as already indicated — the phoenix, the pelican, the mermaid. The owl mobbed by magpies has a deeper than purely decorative significance and suggests the idle busybodies and chatterers of this world mocking at wisdom.

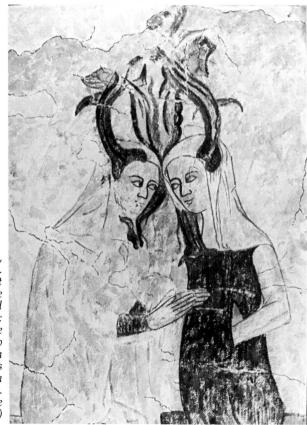

78. Peakirk,
Cambridgeshire.
A warning against
the sin of idle
gossip and
scandalmongering:
a devil on the
shoulders of two
gossiping women
holds their heads
together. Fifteenth
century.
(Watercolour by the
author.)

The signs of the Zodiac sometimes appear, as does the cycle of man's earthly activities, the Labours of the Months, as found in such manuscripts as the Calendar section of *Queen Mary's Psalter* and the *Luttrell Psalter*.

Some of the well loved legends, almost like the *Fables* of Aesop, are strangely absent in wall painting though often met with in wood carving. There was a scene from Reynard the Fox (now destroyed) associated with a St Christopher at Ludgvan, Cornwall; and a fragment of a fox hanged by geese remains on a wall of the Great Hall at Cothay Manor, Somerset.

Many churches retain a few painted consecration crosses. There were originally twelve inside the building and twelve outside, those inside being painted, and those outside carved or scribed. These were anointed with holy oil by the Bishop in the ceremony of consecration. Radnage and Penn (Buckinghamshire), Padworth (Berkshire), Southease (East Sussex), Iffley (Oxfordshire), Ulcombe (Kent), Fairstead (Essex) and many other places retain examples.

79. Easby, North Yorkshire. Pruning, from the Labours of the Months. Mid thirteenth century.

POST-REFORMATION PAINTINGS

It must not be supposed that painting in churches ceased at the Reformation. It took a different form. The religious upheavals of the reigns of Henry VIII, Edward VI and Elizabeth I resulted in a violent reaction against all 'popery', and imagery was frowned on. There was an Order in Council of 1547 for the 'obliteration and destruction of popish and superstitious books and images, so that the memory of them shall not remain in their churches and houses'. All the beautiful paintings were covered by limewash, and their place taken by texts of scripture, 'the sentences' as they were called (Creed, Lord's Prayer and Ten Commandments), and the Royal Arms, ordered to be displayed in every church—and still supposed to be—by Henry VIII after the Act of Supremacy. These texts in elaborate frames were constantly renewed, and they and the intervening coats of limewash often conceal medieval work.

Since imagery was frowned on, very few figure subjects are found. There are Moses and Aaron, usually associated with the Ten Commandments; the symbols of the twelve tribes of Israel (Stoke Dry, Leicestershire; Burton Latimer, Northamptonshire; West Walton, Norfolk; Eyam, Derbyshire); and a curious group, Time and Death — an interesting survival of the medieval preoccupation with mortality.

Then there are exceptional examples like Passenham, Northampton-shire, where the whole chancel, rebuilt by Sir Robert Banastre in 1626-8, has a contemporary scheme of great magnificence. The major prophets, Isaiah, Jeremiah, Ezekiel and Daniel, representing the foretelling of Christ, are on the north; the evangelists (St Mark destroyed by the founder's own monument) showing the fulfilment of Christ, on the south; and Joseph of Arimathea and Nicodemus, representing the Passion, on the east wall. Bratton Clovelly, Devon, seems to have had a similar but much cruder scheme.

The painting of texts continued right up to Victorian times, when they became debased and mechanical, often painted on tin scrolls tacked up. However, there are many very good Victorian schemes of painting, both pictorial and decorative, and these should always be kept when possible.

A remarkable series of seventeenth- and eighteenth-century texts is at Abbey Dore, Herefordshire, some signed and dated by the painter; and there is another at Hawkshead, Cumbria, where the contracts and the names of the artists survive, dating from the late seventeenth and early eighteenth centuries.

FURTHER READING

There are not many books generally available on English wall paintings. The older ones are out of print, and some of the more recent are bulky and expensive. The best source for accounts of individual paintings or sets of paintings will be found in the Journals of the various County Archaeological Societies — Berkshire, Oxfordshire, Essex, Suffolk and Buckinghamshire are particularly good in this respect. It is a disgrace that no upto-date general list of existing or formerly existing wall paintings has been published since Keyser in 1883, a valuable starting point but now hopelessly out of date. Funds have been made available and the Courtauld Institute of Art is supervising a scheme for bringing Keyser up to date and extending the scope of the survey.

Baker, Audrey. *Lewes Priory and the Early Group of Wall Paintings in Sussex*. Walpole Society, volume 31.

Bell, Clive. Twelfth Century Paintings at Hardham and Clayton. Millers Press, 1947.

Bird, W. Hobart. *The Ancient Mural Paintings in the Churches of Gloucestershire*. John Bellows, not dated.

Borenius and Tristram. *English Medieval Painting*. Pegasus Press, 1927. Caiger-Smith, A. *English Medieval Mural Paintings*. Clarendon Press, 1963.

Cather, Sharon; Parke, David; and Williamson, Paul (editors). *Early Medieval Wall Paintings and Painted Sculpture in England*. BAR (British Series) 216, 1990.

Kendon, Frank. Mural Paintings in English Churches during the Middle Ages. Bodley Head, 1923.

Keyser, C. E. List of Buildings Having Mural Decorations. HMSO, 1883. Mora, Paolo; Mora, Laura; and Philippi, Paul. Conservation of Wall Paintings. Icrom, 1984.

Rouse, E. Clive. *The Church of St John the Evangelist, Corby, and Its Mural Paintings*. Privately printed by Strangeways Press for Sir Walter Benton Jones, 1941. Also in *Archaeological Journal*, 1944.

Rouse, E. Clive. 'Wall Paintings in the Church of St Pega, Peakirk, Northants', *Archaeological Journal*, CX (1954).

Rouse, E. Clive; and Baker, Audrey. 'The Wall Paintings at Longthorpe Tower', *Archaeologia*, XCVI (1955).

Rouse, E. Clive; and Baker, Audrey. 'Wall Paintings in Stoke Orchard Church, Glos', *Archaeological Journal*, CXXIII (1967).

FURTHER READING

Tristram, E. W. English Medieval Wall Painting: the Twelfth Century. Oxford University Press, 1944.

Tristram, E. W. English Medieval Wall Painting: the Thirteenth Century. Oxford University Press, two volumes, 1950.

Tristram, E. W. English Wall Painting of the Fourteenth Century. Edited by Eileen Tristram. Routledge and Kegan Paul, 1955.

Wall, J. Charles. Medieval Wall Paintings. Talbot Press, not dated.

Whaite, H.C. St Christopher in English Medieval Wall Painting. Ernest Benn, 1929.

Catalogue of an Exhibition of British Primitive Paintings. Introduction by W. G. Constable. Oxford University Press, 1924.

Conservation of Wall Paintings: Proceedings of the International Symposium on the Conservation of Wall Paintings, 1979. Council for the Care of Churches, 1986.

80. Little Hampden, Buckinghamshire. St Peter with the keys.

GAZETTEER

This is a selective list of churches and other buildings that have wall paintings. Where there are extensive examples or paintings of high artistic importance, the name is marked with an asterisk*.

AVON

Salford Manor, Wellow.

BEDFORDSHIRE

Bushmead Priory, Chalgrave*, Houghton Conquest, Marston Moretaine, Shelton, Sundon, Toddington*, Turvey*, Wymington*.

BERKSHIRE

Aldermaston*, Ashampstead*, East Shefford*, Enborne, Eton (College)*, Ruscombe, Stanford Dingley*, Tidmarsh, Windsor.

BUCKINGHAMSHIRE

Bledlow, Bradwell Abbey*, Broughton*, Chalfont St Giles*, Dorney, Lathbury, The Lee, Little Hampden*, Little Horwood, Little Kimble*, Little Missenden*, Padbury, Penn, Radnage, Swanbourne, Weston Turville, Whitchurch.

CAMBRIDGESHIRE

Bartlow, Barton*, Broughton, Castor, Chesterton, Chippenham, Duxford (St John's; redundant)*, Ely (Cathedral), Glatton, Great Shelford, Haddenham, Hardwick, Hauxton, Ickleton*, Impington, Kingston*, Longthorpe Tower*, Molesworth, Old Weston, Peakirk*, Peterborough (Cathedral), Willingham*, Yaxley.

CHESHIRE

Astbury, Chester (St Mary on the Hill), Marton, Mobberley.

CORNWALL

Breage*, Launcells, Linkinhorne*, Poughill, Poundstock*, St Just in Penwith, St Keverne, Sennen.

CUMBRIA

Hawkshead.

DERBYSHIRE

Dale Abbey, Eyam, Haddon Hall*, Hartington, Melbourne, Taddington, Wingerworth.

GAZETTEER

DEVON

Ashton, Axmouth, Berry Pomeroy Castle, Branscombe, Bratton Clovelly, Exeter (Cathedral)*, Sidbury*, Weare Giffard.

DORSET

Cerne Abbas, Cranborne, Fiddleford Manor, Forde Abbey, Gussage St Andrew*, Tarrant Crawford*, Wareham*, Whitcombe*, Wimborne St Giles (Hospital).

DURHAM

Durham (Cathedral)*, Pittington.

EAST SUSSEX

Arlington, Battle*, Brightling, Mountfield, Patcham, Plumpton, Preston*, Rotherfield*, Southease, Winchelsea.

ESSEX

Belchamp Walter*, Bradwell (near Coggeshall)*, Copford *, Fairstead*, Great Burstead*, Great Canfield, Henham*, Lambourne, Layer Marney*, Little Baddow, Little Easton, Little Tey, Waltham Abbey, Wendens Ambo, White Notley.

GLOUCESTERSHIRE

Ampney Crucis*, Ampney St Mary*, Baunton, Berkeley, Cirencester*, Duntisbourne Rouse, Gloucester (Cathedral), Gloucester (St Mary de Crypt), Hailes*, Kempley*, Oddington*, Shorncote, Shurdington, Stoke Orchard*, Stowell, Tewkesbury.

GREATER LONDON

Carpenters' Company (late medieval wall paintings reset into wall of modern building), East Bedfont*, Hayes, Ruislip*, Tower of London (Byward Tower)*, Westminster Abbey*, Westminster (Chapter House), Westminster Palace (St Stephen's Chapel, now in British Museum), Whitchurch (St Laurence).

HAMPSHIRE

Alton, Ashmansworth*, Bramley*, Breamore, Catherington*, Corhampton*, East Wellow*, Ellingham, Farnborough*, Farringdon (inaccessible)*, Freefolk (redundant), Hartley Wintney (redundant), Idsworth*, Nether Wallop*, Portsmouth (Cathedral), Romsey Abbey, Silchester, Soberton, Tufton, Winchester (Cathedral)*, Winchester (St John's)*.

HEREFORD AND WORCESTER

Abbey Dore*, Byford, Dowles Manor, Harvington Hall*, Hereford (All Saints), Hereford (Black Lion Inn), Martley, Michaelchurch Escley, Pinvin, Wickhamford, Worcester (The Commandery).

HERTFORDSHIRE

Abbots Langley, Cottered, Flamstead*, Newnham, Piccotts End (Hemel Hempstead)*, Ridge, St Albans (Cathedral)*, Sarratt.

HUMBERSIDE

Beverley (Dominican Friary, inaccessible)*, Goxhill, Sledmere.

ISLE OF WIGHT

Bonchurch (Old Church), Godshill, Shorwell.

KENT

Bapchild, Barfreston, Bishopsbourne, Borden, Boughton Aluph, Brook*, Brookland, Canterbury (Cathedral)*, Canterbury (St Mary, Northgate), Canterbury (St Thomas's Hospital)*, Capel*, Cliffe, Darenth, Dartford, Doddington, Dover(College Refectory)*, Eastry, Faversham, Frindsbury, Halling*, Harbledown (St Nicholas), Hastingleigh, Lenham, Littlebourne, Lower Halstow, Newington*, Rochester (Cathedral), Selling, Stone, Ulcombe*, West Kingsdown.

LEICESTERSHIRE

Braunston, Cold Overton, Great Bowden, Great Casterton, Empingham*, Lutterworth, Lyddington, Stoke Dry*.

LINCOLNSHIRE

Caythorpe, Corby Glen*, Friskney, Haceby (redundant), Lincoln (Cathedral), Nettleham, Pickworth*, Ropsley, Stow, Swaton, Swinstead.

MIDDLESEX (see Greater London)

NORFOLK

Attleborough*, Barton Bendish, Belton, Burnham Overy, Catfield, Cawston, Cockthorpe, Crostwick, Fring, Fritton (near Long Stratton), Fritton (near Great Yarmouth), Great Ellingham, Great Hockham*, Haddiscoe, Hardley Street, Hardwick, Hemblington*, Horsham St Faith (Priory; owned by closed order of nuns)*, Little Melton, Little Witchingham*, Moulton St Mary, Norwich (Cathedral)*, Norwich (St Gregory), Paston, Potter Heigham*, Seething*, South Burlingham, South Pickenham, Sporle*, Thurlton, Thurton, Weston Longville, West Somerton*, West Walton, Wickhampton, Wilby.

NORTHAMPTONSHIRE

Ashby St Ledgers*, Burton Latimer*, Canons Ashby*, Chacombe, Croughton*, Doddington, Easton Neston, Easton-on-the-Hill, Glapthorn, Great Harrowden*, Holcot, Nassington, Passenham*, Polebrook, Raunds*, Slapton*, Stanion, Thorpe Mandeville, Towcester.

GAZETTEER

NORTH YORKSHIRE

Bedale, Easby*, Pickering*, Wensley.

NOTTINGHAMSHIRE

Blyth.

OXFORDSHIRE

Baulking, Beckley, Besselsleigh, Black Bourton*, Bloxham, Broughton*, Cassington, Chalgrove*, Charlton-on-Otmoor, Checkendon, Combe, Cropredy, Elsfield, Eynsham, Great Tew*, Hook Norton, Horley, Hornton*, Kelmscott*, Kidlington, Kingston Lisle, Kirtlington, North Leigh, Northmoor, North Stoke, Oxford (Bodleian Library), Oxford (Cathedral and Chapter House), Oxford (Golden Cross, and 3 Cornmarket Street), Rycote Chapel, Shorthampton, South Leigh*, South Newington*, Swalcliffe, Thame, Widford*, Wood Eaton, Yarnton.

SHROPSHIRE

Alveley, Claverley*, Edstaston*, Stokesay, Tong*.

SOMERSET

Cleeve Abbey, Cothay Manor, Farleigh Castle (Hungerford Chapel), Marston Magna, Muchelney, South Cadbury, Sutton Bingham*, Wedmore, Winsham.

SUFFOLK

Alpheton, Bacton, Bardwell*, Barnby*, Boxford, Bradfield Combust, Brent Eleigh*, Chelsworth, Cowlinge, Earl Stonham, Grundisburgh, Hessett*, Hoxne*, Lakenheath*, Little Wenham*, Long Melford*, Martlesham, Mutford, North Cove*, Risby*, Stanningfield, Stoke-by-Clare, Stowlangloft, Thornham Parva*, Troston, Wenhaston*, Wissington*.

SURREY

Albury, Byfleet, Caterham, Chaldon*, Charlwood*, Great Bookham, Pyrford, Stoke d'Abernon, Warlingham, Witley.

WARWICKSHIRE

Burton Dassett*, Curdworth, Stratford-on-Avon (Guild Chapel)*, Stratford-on-Avon (White Swan Inn), Wootton Wawen.

WEST MIDLANDS

Coventry (Holy Trinity)*, Wyken.

WEST SUSSEX

Amberley, Arundel, Boxgrove, Chichester (Bishop's Chapel)*, Clayton*, Coombes*, Hardham*, Trotton*, West Chiltington*, West Hoathly, West Stoke, Wisborough Green*.

WILTSHIRE

Great Chalfield (Church and Manor), Inglesham, Lacock Abbey, Lydiard Tregoze*, Oaksey, Purton, Salisbury (Cathedral), Salisbury (St Thomas's), Sherrington, West Harnham.

WORCESTERSHIRE (see Hereford and Worcester)

It should be understood that there are very many churches where fragmentary or obscure paintings are to be seen. And these the visitor will enjoy discovering and trying to interpret for himself. The list given here is only a summary of the more extensive, interesting or good-quality paintings. Where houses are mentioned, it does not mean that they are open to the public.

There are a number of paintings in Wales (Colwinston, Llangar, Llangybi, Llantwit Major, Ruabon, Rug, St Davids), with many churches having texts; some in the Channel Islands (Catel, St Apolline and St Xavier's in Guernsey, La Houge Bie and St Brelade Fishermen's Chapel, in Jersey) and a very few in Scotland, but these are not considered in detail in this book.

INDEX

For a list of places with wall paintings see gazetteer on pages 74-8. Page numbers in italic refer to illustrations.

Aaron 71
Abbey Dore 71
Abel 38
Abbey Dore 71 Abel 38 Adam 18, 36, 38, 41, 60
Adoration 17
Aesop, Fables of 70
Amersham 27
Amphey Crucis 38
Ampney Crucis 38 Ampney St Mary 68 Annuciation 15, 22, 39,
Appunciation 15 22 20
41, 44
Apocryphal gospels 41 Apostles' Creed 26
Argument 17
Arundel 64
Psalter 61, 66
Ascension 41 Ashridge 28
Ashridge 28
Azurite 25
Babel, Tower of 38 Baker, William 52
Baker, William 52
Banastre, Sir Robert 71
Baptism 41
Battle 53, 53, 54, 55
Baunton 48
Baunton 48 Beauvais, Vincent de 54
Belchamp Walter 48 Bestiaries 27, 48, 69 Betrayal 12 Bible 35, 38
Bestiaries 27, 48, 69
Betrayal 12
Bible 35, 38
Poor Man's 13
Biblia Pauperum 13
Bishop Cousin's Library
28
Black Death 67 Blasphemers 62
Blasphemers 62
Blasphemy 67
Blasphemy 67
Blasphemy 67
Blasphemy 67 Bledlow 37, 38 Blessing 16, 17
Blasphemy 67 Bledlow 37, 38 Blessing 16, 17 Bradwell Abbey 44, 53 Bratton Clovelly 71
Blasphemy 67 Bledlow 37, 38 Blessing 16, 17 Bradwell Abbey 44, 53 Bratton Clovelly 71
Blasphemy 67 Bledlow 37, 38 Blessing 16, 17 Bradwell Abbey 44, 53 Bratton Clovelly 71
Blasphemy 67 Bledlow 37, 38 Blessing 16, 17 Bradwell Abbey 44, 53 Bratton Clovelly 71 Breage 63, 68 Broughton 30, 61, 67
Blasphemy 67 Bledlow 37, 38 Blessing 16, 17 Bradwell Abbey 44, 53 Bratton Clovelly 71 Breage 63, 68 Broughton 30, 61, 67 Button Latimer 71
Blasphemy 67 Bledlow 37, 38 Blessing 16, 17 Bradwell Abbey 44, 53 Bratton Clovelly 71 Breage 63, 68 Broughton 30, 61, 67 Burton Latimer 71 Bury St Edmunds 19-20
Blasphemy 67 Bledlow 37, 38 Blessing 16, 17 Bradwell Abbey 44, 53 Bratton Clovelly 71 Breage 63, 68 Broughton 30, 61, 67 Burton Latimer 71 Bury St Edmunds 19-20 Cain 38
Blasphemy 67 Bledlow 37, 38 Blessing 16, 17 Bradwell Abbey 44, 53 Bratton Clovelly 71 Breage 63, 68 Broughton 30, 61, 67 Burton Latimer 71 Bury St Edmunds 19-20 Cain 38 Callixtus II. Pope 55
Blasphemy 67 Bledlow 37, 38 Blessing 16, 17 Bradwell Abbey 44, 53 Bratton Clovelly 71 Breage 63, 68 Broughton 30, 61, 67 Burton Latimer 71 Bury St Edmunds 19-20 Cain 38 Callixtus II, Pope 55 Cana, Marriage at 44
Blasphemy 67 Bledlow 37, 38 Blessing 16, 17 Bradwell Abbey 44, 53 Bratton Clovelly 71 Breage 63, 68 Broughton 30, 61, 67 Burton Latimer 71 Bury St Edmunds 19-20 Cain 38 Callixtus II, Pope 55 Cana, Marriage at 44 Canterbury Cathedral
Blasphemy 67 Bledlow 37, 38 Blessing 16, 17 Bradwell Abbey 44, 53 Bratton Clovelly 71 Breage 63, 68 Broughton 30, 61, 67 Burton Latimer 71 Bury St Edmunds 19-20 Cain 38 Callixtus II, Pope 55 Cana, Marriage at 44 Canterbury Cathedral 16, 20, 20
Blasphemy 67 Bledlow 37, 38 Blessing 16, 17 Bradwell Abbey 44, 53 Bratton Clovelly 71 Breage 63, 68 Broughton 30, 61, 67 Burton Latimer 71 Bury St Edmunds 19-20 Cain 38 Callixtus II, Pope 55 Cana, Marriage at 44 Canterbury Cathedral 16, 20, 20
Blasphemy 67 Bledlow 37, 38 Blessing 16, 17 Bradwell Abbey 44, 53 Bratton Clovelly 71 Breage 63, 68 Broughton 30, 61, 67 Burton Latimer 71 Bury St Edmunds 19-20 Cain 38 Callixtus II, Pope 55 Cana, Marriage at 44 Canterbury Cathedral 16, 20, 20
Blasphemy 67 Bledlow 37, 38 Blessing 16, 17 Bradwell Abbey 44, 53 Bratton Clovelly 71 Breage 63, 68 Broughton 30, 61, 67 Burton Latimer 71 Bury St Edmunds 19-20 Cain 38 Callixtus II, Pope 55 Cana, Marriage at 44 Canterbury Cathedral 16, 20, 20 Castor 14 Caxton 55 Chaldon 60
Blasphemy 67 Bledlow 37, 38 Blessing 16, 17 Bradwell Abbey 44, 53 Bratton Clovelly 71 Breage 63, 68 Broughton 30, 61, 67 Burton Latimer 71 Bury St Edmunds 19-20 Cain 38 Callixtus II, Pope 55 Cana, Marriage at 44 Canterbury Cathedral 16, 20, 20 Castor 14 Caxton 55 Chaldon 60 Chalfont St Giles 18,
Blasphemy 67 Bledlow 37, 38 Blessing 16, 17 Bradwell Abbey 44, 53 Bratton Clovelly 71 Breage 63, 68 Broughton 30, 61, 67 Burton Latimer 71 Bury St Edmunds 19-20 Cain 38 Callixtus II, Pope 55 Cana, Marriage at 44 Canterbury Cathedral 16, 20, 20 Castor 14 Caxton 55 Chaldon 60

Cl. 1 20 20 44
Chaigrove 20, 30, 44
Charcoal black 25
Chalgrove 20, 30, 44 Charcoal black 25 Charlwood 67
Chaucer 64, 67, 69
Chichester, Bishop's
Delega 52
Palace 53
Christ 10, 18, 33, 36,
Christ 10, 18, 33, 36, 41, 43, 50, 57, 60, 61
62 63 67 68 71
Ascension of 41 Baptism of 28, 29, 41 Child 8, 23, 34, 45 Crucifixion of 41, 4
Bantism of 28 20 41
Child 9 22 24 45
Cilid 8, 23, 34, 43
Crucifixion of 41, 4
Infancy of 41
Infancy of 41 in Judgement 65
in Majesty 29, 33
Life of 41
Life of 41 Nativity of 39, 41, 5
Nativity 01 39, 41, 3.
of the Trades 68
Passion of 10, 36, 39
41, 55, 71
Resurrection of 41, 4
Christ Church Cathedral
35
Cistercian 61
Clarendon 21
Cistercian 61 Clarendon 21 Claverley 61
Clayton 20 24 37 31
Close Rolls 21
Close Rolls 21 Condemnation 17
Condemnation 17
Coombes 11, 15, 20, 24, 24, 25, 33, 37, 41,
24, 24, 25, 33, 37, 41,
42, 51
Copford 44, 61
Copper salt 25
Corby Glan 12 29 40
Copper salt 25 Corby Glen 12, 38, 40, 47, 55, 58, 61, 62, 67
47, 55, 58, 61, 62, 67
Corhampton 53
Cothay Manor 26, 70
Coventry 55
Creed 71
47, 33, 36, 61, 62, 67 Corhampton 53 Cothay Manor 26, 70 Coventry 55 Creed 71 Croughton 44, 53 Crucifixion 22, 23, 41,
Croughton 44, 33
Crucifixion 22, 23, 41,
40
Daniel 38, 71
Danse Macabre 67
David cover, 26
and Goliath 27 39
and Goliath 27, 38
Death 65
Black 67
Dance of 67
Dance of 67 Time and 71
Desert of Religion 69
Devil 61, 62, 69
Devii 01, 02, 09
Dives and Lazarus 42, 4
Doom 17, 30, 56, 57, 6

Dragon 65	8,	45,	49,	50,	55
Duntisb	our	ne F	Rous	se	37
Durham		16			
Bisho	p C	ous	in's		
Libr	ary	2	8	150	
Cathe	dra	1, 0	anne	e	
Cha Earth co	lo	1/	25		
Easby	41	70	23		
Edward	I	23			
Edward	III	2	1		
Edward Edward Edward Elijah	VI	7	1		
Elijah	27				
Elizabel	11 1	/	1		
Eton Co	lle	ge C	hap	el	52
Euchari	st	48			
Eusebiu	S	. 54	0 5	7 7	11
Eucharis Eusebiu Evangel symbol Eve 18	le	of 4	26	32	-
Eve 1) 15 R 3	63	8 4	1 6	0
Expostu	lati	on.	17	1,0	
Evam	71		-		
Eyam Ezekiel	7	1			
Fairstea	d	44,	70		
Flight in	ito	Egy	pt	41,	42
Fresco	23	3			
Frindsb	ury	3	0		
Furnace Fiery	, B	urni	ng		
Fiery	3	8			-0
Garden	of .	บยแ	gnis		9
Gilbert Glaptho	- D	20			
Glouces	ter	Cat	, hedi	ral	2
God H	and	of	17	ai	2,
God, Ha Golden	Cro	oss	28		
Golden Good Sa Great B	Les	gena	1 5	4	
Good Sa	ama	arita	n	44	
Great B	urs	tead	3	9	
Hadden	har	n :	37		
Hadden Hailes	30), 3	8, 6	9	
Hardhar	n	24,	36,	38,	
41, 51			11	27	
Harving				21	
Hawksh Hayes	16	1 /	1		
Hell 1	7	57			
Harro	Wit	100	f 6	60	
Henry I	II	21.	26.	38	
Henry I	/III	7	1		
Heraidr	y	20			
Herod,	Kin	g	12, 1	5, 1	18,
18, 55					
Herod's			8, 1	18	
Hessett	6	8			

5,	Hildburgh, Dr 55 Hortus Deliciarum 69 Ickleton 12 Iffley 70 Inglesham 30 Iron, oxides of 25 Isaiah 71 Israel, twelve tribes of 71 Jairus's Daughter, Raising of 44 James, Provost M. R. 52 Jeremiah 71
2	Jericho, Walls of 38 Jerusalem, Heavenly 57 Jesse, Tree of 44 Jews 15 Joseph 38 Joseph of Arimathea 71 Judgement 17. See also Last Judgement Judith and Holofernes 27
!	Kempley 20, 24, 64 King Reason 28 Knowledge, Tree of 60 Labour, Consecration of 68 Labours of the Months
7	27, 29, 70, 70 Lakenheath 16 Lamp black 25 Langland 68, 69 Lapis lazuli 25 Last Judgement 30, 57, 58, 60
	Last Supper 12 Lazarus, Raising of 44 Legenda Aurea 54 Liberlate 21 Lime 25 Linkinhorne 61 Lisle, Psalter of Robert de 66 Listening 17 Little Hampden 30, 31, 61, 73 Little Kimble 30, 48, 49, 52 Little Melton 68 Little Missenden 31, 51 Little Wenham 20, 25 Llantwit Major 34, 37 Longinus 10, 18, 36

Longthorpe Tower	Pseudo-Abdias 55	St Michael 59, 61	Protecteur (Vierge de
cover, 25, 26, 28, 29,	Pyrford 61	St Miniato, Florence 68	Miséricorde) 61
48, 64-5, 67	Queen Mary's Psalter	St Nicholas 48, 50	Villon, François 58
Lord's Prayer 71	61, 70	St Osyth 23	Virgin Mary 15, 23, 40,
Ludgvan 70	Radnage 70	St Paul 20, 27	41, 44, 44, 50, 57, 60,
Luttrell Psalter 70	Raunds 65, 67	St Peter 29, 57, 73	61, 62, 67
Lydgate 69	Red Sea 38	Martyrdom of 12	and Child 22, 41, 44,
Maccabees 38	Reformation 71	St Swithin 53	53
Malta 20	Resurrection 41, 48	St Thomas à Becket 22,	Coronation of $8, 22,$
Manus Dei 17	General 57	53	41
Maxentius, Emperor 14	Reynard the Fox 26, 27,	Martyrdom of 50	cult of 53
Mermaid 48, 69	70	Salford Manor 26	Life and Miracles of
Miracles 44	Risby 37, 51	Salisbury, St Thomas's	30, 44, 52
Mirk, John 69	Rochester 65	church 56, 60	Virtues 61
Morris, William 30	Rosary 23, 61	Salome 18, 18	Voragine, Jacobus de 54
Moses 27, 38, 71	Royal Arms 71	Salutation 15	Wakefield 55
Nassington 48	Ruabon 67	Salvation, Ladder of 60	Wareham 50
Nativity 26, 39, 41, 55	Ruislip 64, 65	Samson 41	Warning
Nebuchadnezzar 38	Sabbath-breakers 63, 68	Santa Claus 48	against idle gossip 68,
Nether Wallop 49, 68	St Albans Cathedral and	Secco technique 25	69
New Testament 35, 38	Abbey Church 16, 19,	Seven Ages of Man 27	the Three Living and
Nicodemus 71	21, 22, 25, 28, 35, 44	Seven Corporal Works of	the Three Dead 26,
Nine Worthies 27		Mercy 61, 65, 65,	36, 63, 66-7, 66
	St Andrew, Martyrdom of		
Noah 38	12	67	to blasphemers 62
Norsemen 6	St Anne 40, 44, 50	Seven Deadly Sins 57,	to sabbath-breakers
North Cove 60	St Anthony Abbot 27,	60, 64, 64, 65, 65	<i>63</i> , 68
Norwich 16, 19	29, 48	Shepherds 12	to swearers 62, 67
Ochre 25	St Bernard 49	Shorwell 48	Weighing of Souls 53,
Old Testament 35, 38		Skeletons 66, 66	59, 60, 61
	St Catherine 14, 16, 31,		
Owst, Professor 68	45, 48, 49, 53	Soul 17	Wensley 67
Padbury 30, 43, 64, 65	burial of 49	Souls, Weighing of 53,	West Chiltington 20,
Padworth 70	Life of 31, 52	59, 60, 61	39, 44, 51, 68
Painter-stainers' Guild	St Christopher 6, 8, 30,	Southease 70	West Kingsdown 30, 38
23	31, 34, 36, 38, 45, 45,	South Newington 20	Westminster 13, 19, 21,
Parables 44	46, 47, 63, 70	Speculum Historiale 54	23
Paris, Matthew 19, 21	St Citha 22	Speech 15, 17	Palace of 26, 38
Passenham 71	St Clare 48	Sporle 14, 16, 51, 52	Weston Turville 37
Passion 10, 36, 39, 41,	St Clement 29	Stanion 59	West Walton 71
55, 71	St Cuthbert 17	Stoke Dry 6, 71	Wheel 14, 31, 45, 64
instruments of 57	St Davids Cathedral	Stoke Orchard 33, 37,	of Fortune 64
Peakirk 10, 18, 36, 43,	32-3	38, 51, <i>51</i> , 55	of Life 27, 64
44, 67, 68, 69	St Edmund 16, 43, 53	Supplication 17, 60	of the Five Senses 27,
Pelican 48, 69	Martyrdom of $6, 8, 50$	Supremacy, Act of 71	28, 64
Penn 70	St Eligius (St Eloy) 48	Swanbourne 68	of the Seven Sins 64
Peterborough 20	St Francis 48	Swearers 62, 67	of the Virtues 64-5
Phoenix 48, 69	St George 8, 30, 45, 49,	Tarrant Crawford 51,	Whitcombe 45
Piccotts End 28, 28, 29,	50	55, 63, 66, 67	Widford 67
55	St James the Great 33,	Ten Commandments 71	Winchester 16, 19, 20,
Pickering 8, 44, 50	<i>36</i> , <i>51</i> , <i>55</i>	Three kings 63, 66	21, 44, 52, 53
Pickworth 67	St Jerome 54	Three Living and Three	Windsor 21, 26
Piers Plowman 68	St John the Baptist 18,	Dead 26, 36, 63,	Wisborough Green 36
Pietà 29	18, 28, 52, 57	66-7, 66	Wonder 17
Plastérers' Guild 23	St Just in Penwith 68	Tobit 27	Wounds, Five 57, 67,
Plumpton 37, 51	St Margaret 45, 48, 53,	Tristram, Professor 52,	68
Poughill 30	53	68	York 55
Poundstock 68	Life of 53, 54, 55	Trotton 65	York Minster 35
Power 17	Martyrdom of 52	Ulcombe 42, 44, 70	Zodiac 70
Prayer 17	St Mark 33, 71	Vermilion 25	
Pride 64, 65	St Martin 48, 50, 50	Vices 61	
Prodigal Son 27, 44	St Matthew 61	Vierge Manteau	